IMAGES
of America

REDWOOD CITY

IMAGES
of America

REDWOOD CITY

Reg McGovern, Janet McGovern,
Betty S. Veronico, and Nicholas A. Veronico

ARCADIA
PUBLISHING

Published by Arcadia Publishing
Charleston, South Carolina

Printed in the United States of America

Library of Congress Catalog Card Number: 2008928307

For all general information contact Arcadia Publishing at:
Telephone 843-853-2070
Fax 843-853-0044
E-mail sales@arcadiapublishing.com
For customer service and orders:
Toll-Free 1-888-313-2665

Visit us on the Internet at www.arcadiapublishing.com

*This book is dedicated to the memory of Raymond L. Spangler, publisher
of the* Redwood City Tribune.

Dona Maria Soledad Ortega Arguello, pictured
here in 1874, was the wife of Don Luis Arguello,
the first native-born governor of California
and owner of Rancho de las Pulgas. The land
Redwood City now occupies was once a large
portion of the rancho. (Redwood City Library.)

CONTENTS

ACKNOWLEDGMENTS

The authors wish to thank the following for their assistance in preparing this book: Robert Anderson; Rachel and David Anderson; Dominique, Sheridan, Donte, and Cheyenne Anderson; Caroline and Ray Bingham; Claire and Joe Bradshaw; Arlene and Rich Bradshaw; Vince Bravo; Michelle Conci; Rhonda and Bruce Cumming; John Edmonds; Rev. Chip Barker Larrimore; Dennis Logie; Michael Ratliff Lutz; Jo Anne Montoya; Peggy Newman; Bill O'Hanlon; Carol Peterson; Shirley Schworer; Mary K. Spore-Alhadef; Tammie Veach; and Karen and Armand Veronico.

—Reg McGovern
Janet McGovern
Redwood City, California

—Betty S. Veronico
Nicholas A. Veronico
San Carlos, California

The first arched Redwood City sign was contracted for in 1926. The sign was installed at the north end of town at El Camino Real and Broadway, stood 20 feet above the street, and had 3-foot-tall white illuminated letters. A second sign was installed at the south entrance to town at the Five Points intersection. This 1929 photograph shows police officers standing beside the city's first patrol car. (Redwood City Library.)

INTRODUCTION

Redwood City, like many small towns of the San Francisco peninsula, began as part of a Mexican rancho. The 35,420-acre Rancho de las Pulgas extended from the San Francisciquito Creek near Palo Alto to San Mateo Creek and from the bay marshes to what is now Cañada Road. Rancho de las Pulgas was granted to the ninth governor of Alto California, Capt. Don Dario Arguello, by the Mexican government for dedication to duty. The land was passed to his son, Don Luis Arguello, who became the first native-born governor to serve under the Mexican regime. After Don Luis's death in 1830, his widow, Dona Maria Soledad Ortega Arguello, moved from the San Francisco Presidio to an adobe home on the rancho's grounds. In 1854, Arguello began selling parcels of the rancho.

Before the Arguellos could begin selling legal parcels of the rancho, clear title had to be established. After the Mexican-American War ended, questions arose as to who owned the land and how much. After California became a state in 1851, landowners had to defend their title before the U.S. Land Commission. If the titles did not hold up, the original landowner lost his land and squatters could claim the title.

Attorney Simon Montserrate Mezes had proven himself a trustworthy advocate for Mexican landowners and was hired by the Arguellos to defend their claim. After successfully moving the title through the U.S. Land Commission, Mezes was hired to manage the rancho's affairs. For his services, Mezes received one-fourth of the land, including what was to become downtown Redwood City.

Mezes soon had surveys conducted, maps were made outlining where streets should be, and he filed paperwork to have the city named Mezesville. The squatters were told to pay the asking price of $75 per lot or leave. In order to retain the land they were living on, most squatters eventually paid and obtained the deed to their land.

Three parcels of land were given to Redwood City by the Arguellos and Mezes. The first was California Square at Marshall and Winslow Streets, where the Hall of Justice now sits. The second was Mezes Park, a 1.7-acre park on Warren and Standish Streets commonly called "Tank Park" for the tank that currently sits in the southwest corner. In 1856, when San Mateo County was established and Redwood City was chosen as the county seat, Mezes donated the third parcel for a new courthouse in the block bordered by Broadway, Hamilton Street, Marshall Street, and Middlefield Road.

By the dawn of the 20th century, the city was growing at a brisk pace. In 1920, a boy named Reginald was born to Hilda and Thomas C. "Brick" McGovern, soon to become San Mateo County sheriff. Young "Reg," as he like to be called, grew up on Arch Street and in his teens became a shutterbug. In the late 1930s, he was given some assignments for the *Redwood City Tribune*, where he would later spend his career as an award-winning photojournalist. Reg McGovern's photographs are a time capsule of 20th-century Redwood City, and his legacy is a gift to its residents. This visual journey through the history of Redwood City is built from that legacy.

Among the numerous lumber companies founded in the city, the Redwood City Lumber Company had its main office at 701 Spruce Street. The company was formed by G. F. Gray in 1891, changed hands in 1910, and was renamed Gray-Thorning Lumber Company. Gray-Thorning's slogan was "The house of quality redwood and pine lumber." Workers and their horse-drawn buggies are shown here in 1897. (Redwood City Library.)

A common sight in Redwood City were the hundreds of lumber wagons rolling through town. In 1910, a team of horses pulling a lumber wagon stops in front of the Redwood City Public (Grammar) School as it heads toward the port to unload its cargo. (Redwood City Library.)

One

EARLY DAYS
FROM RANCHO TO COUNTY SEAT

By the mid-1800s, Redwood City was a thriving town, with its port supporting most of the commerce. Lumber companies began forming along the waterfront, and streets were used not only for the horse and buggies (and later "horseless" carriages) of the towns' people, but many became major thoroughfares for the lumber wagons heading to the port. Businesses of all types began to appear along Main Street and Broadway to support the growing population, including tanneries, hotels, restaurants, and theaters.

The Consolidation Act of 1856 was introduced to the legislature by State Assemblyman Horace Hawes. The act consolidated the boundaries of the City and County of San Francisco and set apart all rural areas of San Francisco County into a new unit called San Mateo County. A county seat had to be selected, and after a fraudulent election, a second election was held. In April 1857, Redwood City was declared the San Mateo County seat.

Becoming the county seat brought new prospects to the city and its residents. Government positions increased and many prominent Redwood City figures held various offices, including Assemblyman Hawes who owned a large estate where Sequoia High School is currently located, Benjamin Fox (county judge), John Ackerson (the county's first sheriff), and Benjamin Lathrop (San Mateo County's first county clerk, recorder, and auditor), to name a few.

Prior to construction of the first courthouse, Diller's store on Main Street was the chosen location where most of the county business was conducted. Redwood City has had four courthouses built in the block donated by Simon Mezes. The first courthouse was completed in 1858, the second courthouse in 1882, the third in 1906 (destroyed by the earthquake and never occupied), and the fourth courthouse was completed in 1910. It now houses the San Mateo County History Museum.

When the train from San Francisco to San Jose was completed in 1864, Redwood City became the place to be for wealthy San Franciscans. The mild climate ("Climate Best by Government Test") and available land had businessmen purchasing lots and building large summer homes, which eventually became full-time residences, and the first commuters began taking the train to and from work on a daily basis. As the town became more popular, land prices increased and improvements to the city's infrastructure were needed. With this, the citizens petitioned for incorporation in 1867. On March 27, 1868, Redwood City became the first city in San Mateo County to incorporate.

By the turn of the century, the lumber business had all but ceased in the area. However, Redwood City continued to thrive. The Embarcadero, as the waterfront was known, continued to employ a great number of people, construction workers prospered as the demand for new buildings increased, and education and farming communities lured others.

The deep waterways and proximity to the bay provided Redwood City with a thriving economy. The Redwood Creek, shown here at low tide, was used to ship logs that had been cut from the peninsula hills, brought to the city by horse or oxcart, and then sent off to the bay, where they were transported to San Francisco. Redwood Creek and the port would become a vital part of Redwood City. (Library of Congress.)

Lumbermen Frank Weeks (with bullwhip) and Walter Ray are shown driving a five-yoke team (10 oxen) down a skid road from Dudfield Mill (now Loma Mar) in 1900. The ox teams proved to be an integral part in transporting the lumber from the mills to the port. Present-day Woodside Road and Whipple Avenue were two of the major thoroughfares. (Redwood City Library.)

Simon Montserrate Mezes, attorney to the Arguellos, was deeded part of their ranchero as payment for establishing clear title to their land in 1853. The land deeded to Mezes was what is now downtown Redwood City. Mezes filed an official plot map for his new town and named it Mezesville. (Redwood City Library.)

The name Mezesville was not well received by the squatters who now had to purchase their land from Mezes. Rebellious, they called the new town Redwood, Redwood Landing, and finally, in 1856 when a post office was established, Redwood City became its official name. Mezes donated land for the courthouse and a park, seen to the lower left of this 1925 photograph. This was one of the first private parcels donated for public recreation in California. (Redwood City Library.)

The first courthouse for San Mateo County was built in 1858 on land donated by Mezes. The courthouse was originally a two-story building, seen here in the center, until an earthquake in 1868 damaged the building. The second story was so badly damaged that it had to be removed. The building was demolished in 1884, two years after the second San Mateo County Courthouse was built. (Library of Congress.)

This 1866 view from the north shows the humble beginnings of what would become the thriving downtown area of Redwood City. The original courthouse can be seen in the center. (Library of Congress.)

Redwood City held many social events. One of the popular events of the early 1900s was the Married Men vs. Single Men baseball game. Four of the Married Men team members (including C. L. Collins, second from the left, and James D. Hedge, right), and one junior, pose for the camera before the big game. (McGovern Collection.)

In 1915, the Redwood City band marches past the Bell Theater at 865 Main Street to celebrate the Married Men vs. Single Men baseball game. (McGovern Collection.)

This 1915 parade down Broadway, past the courthouse, shows the transition from horse and buggy to the more popular "horseless carriage." (McGovern Collection.)

In 1902, concrete millionaire William Dingee purchased 3,000 acres of land from Horace Hawes in the area that is now part of Sequoia High School and built a magnificent home with elaborate gardens. The 1906 earthquake destroyed the home, and in 1907, Dingee sold the land to a developer. This advertisement touts Dingee Park's half-acre lots selling for as little as $600, with a special train ride from San Francisco to view the lots. (Veronico Collection.)

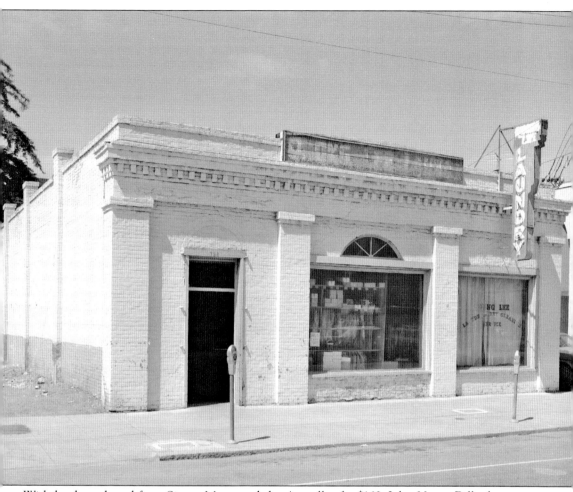

With land purchased from Simon Mezes and the Arguellos for $160, John Vogan Diller began construction on the "Old Pioneer Store" on June 4, 1859, and it opened in July 1859. Located at 726 Main Street, the store was originally built with two identical storefronts, one on Main Street and the other facing Redwood Creek, which, at the time, backed up to the building. In 1867, Diller became Redwood City's first mayor. Philander P. Chamberlain purchased the store in 1887. A Wells Fargo Express Agency was located at the store from 1875 until 1911, and it served as the county treasurer's office while Chamberlain held that office from 1885 to 1925. From 1918 to 1919, the building housed classrooms for the Redwood City Aviation School, and it was sold to Gony Yuey in 1950 and became a laundry. The Dillar-Chamberlain Store is the oldest brick commercial building in Redwood City. (Library of Congress.)

Built in the 1880s, this 1905 photograph shows gentlemen standing in front of the Five Point Hotel, located at the intersection of El Camino Real, Redwood Avenue, Woodside Road, Main Street, and Spruce Street, hence the name Five Point. Lumber wagons passed this location as they came from the peninsula hills, down Woodside Road, then continued along Main Street to the Embarcadero—as the city's port district was then known. (Redwood City Library.)

Victor Bernasque purchased Five Point Hotel in 1910 and had the original hotel moved to the back of the property, where it was said to have been used as a discreet lodge for "working" women. He then built Bernasque's Hotel and Café at the front of the property, facing the intersection. The café's name was changed to The Fly Trap Inn when the property sold to San Francisco residents C. Tognoli and J. Garofili in 1919. In that same year, the original hotel was demolished. Bernasque's Café was well known for its French food and The Fly Trap Inn for its liquid spirits during Prohibition. (Redwood City Library.)

The Ancient Order of United Workman (AOUW), Redwood City Lodge 25, was built in 1895 and located in the 200 block of Main Street in the Odd Fellows Building. The upper floor was used for meetings, while the street level was rented to small businesses. The Alhambra Theater and Bar sat on one side and the livery stable on the other. (Redwood City Library.)

Constructed in 1914, this original Redwood City sign spanned Broadway at Winslow Street near the train depot. It was hung with wires that lit the bulbs in each letter and was visible from either direction. (Redwood City Library.)

Constructed just six years before the 1906 earthquake, the First National Bank of San Mateo County, made primarily of brick, did not fare well when the shaking started. The building, located at the corner of Main Street and Broadway, sustained major damage, including the cupola toppling from its perch atop the two-story building. The structure was repaired but was later neglected. The building was restored to its original grandeur in 1963 and is used today as professional offices. (Redwood City Library.)

The second courthouse for San Mateo County was completed in 1882. It proved too small after 22 years of service, a new courthouse was planned, and construction began. On July 4, 1904, the cornerstone for the new courthouse was laid. Seen behind the 1882 courthouse is the framework for the new dome that would top the third courthouse. (Redwood City Library.)

The centerpiece of the third courthouse was an Italian Renaissance–style, 16.5-foot-wide, steel-ribbed glass dome. After 18 months of construction, the building was just about complete and ready to be occupied when catastrophe hit. On April 18, 1906, the great earthquake destroyed all but the dome and foundation of the building. (Redwood City Library.)

The aftermath of the 1906 earthquake was evident as the courthouse was all but destroyed. The second courthouse, seen on the right with the Liberty statue still atop, was originally incorporated into the new building. However, the earthquake damaged it beyond repair, and it was demolished with the rest of the building. (Redwood City Library.)

The fourth courthouse of San Mateo County was completed and officially occupied on June 23, 1910. The dome stands today as it did when it was originally installed in 1904. (Bradshaw Collection.)

Founder of the Redwood City Airport, Silas Christofferson is seen here at the controls of an early pusher-powered airplane. Christofferson established the airport, which he named Lynch Field, and an aviation school in 1916 at the south end of Redwood City at what is now Chestnut Street between Veterans Boulevard and Broadway. Christofferson died the same year in an airplane crash. (Redwood City Library.)

In 1917, after Silas Christofferson's death, Frank Bryant purchased the land and aviation school and renamed it Redwood City School of Aviation. In 1920, the business was sold to World War I flying ace Walter Varney, founder of United Aircraft and Transportation Company, which became United Airlines. Planes are seen lined up in front of Varney Flying School in 1925. The airport continued operation until the early 1930s, when the land was sold to developers. (Redwood City Library.)

Built with a $10,000 grant from the Carnegie Foundation, the Carnegie Library was located at the corner of Broadway and Jefferson Avenue and served the community until 1939. However, service was disrupted after the 1906 earthquake caused $6,000 in damage, which the Carnegie Foundation provided for repairs to the building and its contents. The Red Cross used the building during World War II, and it was demolished in 1948. (Veronico Collection.)

The Eastern Addition subdivision was bordered by El Camino Real to Phelps Street (now Middlefield Road) and from Main Street to Chestnut Street. The subdivision was annexed to Redwood City in the 1870s. The S. H. Frank Tannery can be seen in the center of the background. (Redwood City Library.)

Located at 1204 Middlefield Road, formerly Phelps Street, Foresters Hall was built in 1913 for the Foresters of America. The building was a state-of-the-art neoclassical design with exterior columns, 14-foot-high open truss ceilings, a maple dance floor with stage, and kitchen facilities. It was the place to be for social and private events. The building was sold and refurbished in the 1990s and continues to be a community meeting venue. (Redwood City Library.)

The first Redwood City subdivision west of El Camino Real was Wellesley Park, bordered by Edgewood Road, El Camino Real, Arlington Road, and Hudson Street, and developed by the Wellesley Land and Improvement Company. In 1889, two Abyssinian lion statues were placed at the entrance to the 153-lot development on Wellesley Crescent. The pair continues to stand guard today, watching over Wellesley Park. (Redwood City Library.)

As the Redwood Creek began silting in, wharves were moved closer to the bay. As a result, a drawbridge was built over the creek at Bradford Street in the early 1900s. The Redwood City Fire Department is testing the pumps of its new Seagrave fire truck off the bridge in 1926. The Fox-McNulty Lumber Company can be seen in the background. (Redwood City Library.)

The corner of El Camino Real and Vera Avenue was the location for the original Davies Auto Repair. Nelson Davies opened its doors in 1916 and provided customers with automobile service that included cleaning and repairing as well as sales. In 1923, brothers Albert and Thomas took over, adding a Willys-Knight Overland dealership, and by the early 1930s, a Chevrolet dealership was serving customers. The business was relocated to the corner of El Camino Real and Jefferson Avenue in 1942, and in 1990, the Davies clan sold the oldest family-owned Chevrolet dealership in Northern California. (Reg McGovern.)

The Redwood Theater, located on the corner of California and Winklebeck Streets, was designed by S. Charles Lee in the art moderne style. The single-screen theater was built in 1933 and sat 562 moviegoers. It was known as "the little theater of big pictures" and featured two movies on each program. (Reg McGovern.)

The Redwood Theater was closed in 1955 after 22 years of business. Demolition workers can be seen on the roof preparing the building for its demise. After the theater was demolished, a branch of Bank of America was built on the site, and currently Anderson TV/Video occupies the location. (Reg McGovern.)

The first theater to bear the name Sequoia Theater originally opened in 1917 at 2114 Broadway. The Sequoia entertained countless patrons until seating demand outgrew capacity. In 1929, the original Sequoia Theater was closed and a new, 1,400-seat venue carrying the same name was opened down the block. (Redwood City Library.)

In order to house the growing number of movie buffs, a larger theater was built just up the street at 2215 Broadway. The new Sequoia Theater was designed in the Moorish style by Reid and Reid Architects of San Francisco while the interior was Gothic Revival. The building spanned the block and opened its doors in 1929. The employees of the theater stand ready in this 1930 photograph. (Redwood City Library.)

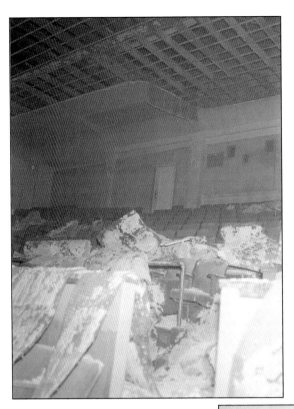

On June 22, 1950, disaster hit the Sequoia Theater when the balcony ceiling plaster and reinforcement fell, injuring 30 people. (Reg McGovern.)

After months of repair, the theater reopened on September 15, 1950, to tremendous fanfare. The name was soon changed to the Fox Theater. In 1994, the Fox Theater building was added to the National Register of Historic Places. (Redwood City Library.)

Thomas C. "Brick" McGovern, father to coauthor Reg McGovern, was the 16th sheriff of San Mateo County. He served from 1924—shortly after Sheriff H. W. Lampkin died in an auto accident on December 23, 1923—through 1927. McGovern died in 1927 from injuries sustained in an auto accident. Here in 1925, McGovern holds the keys to the jail on Middlefield Road, across from the courthouse. (Hilda McGovern.)

The 1928 California Highway Patrol motorcycle officers and their bikes are seen in front of courthouse on Broadway. (McGovern Collection.)

The San Mateo County sheriff's office and jail was on Middlefield Road. The deputy cars of 1929 are parked in front. (McGovern Collection.)

The California Highway Patrol office was located at Middlefield Road and Marshall Street. Shown in 1937, officers and their vehicles stand at attention ready for their Saturday inspection. (Reg McGovern.)

On November 21, 1945, the Redwood City Fire Department shows off its trucks in front of Station No. 2. The station, located at Jefferson Avenue and Myrtle Street, was built in 1928. In 1981, the building was demolished and a new fire station, renumbered to Station 10, was constructed on the site. (Reg McGovern.)

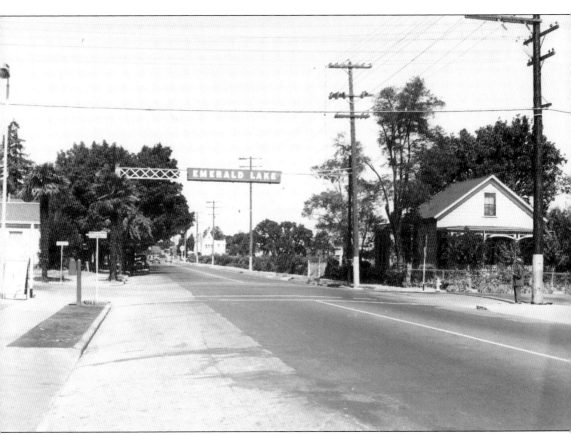

In the 1920s, Emerald Hills, located in the unincorporated western section of Redwood City, was envisioned by developers as a summer retreat for busy San Franciscans, but this never materialized. The area has two lakes with emerald water, Handley Rock Park that features a 50-foot monolith of sandstone, the Easter Cross, and a country club. In 1968, Emerald Hills had 430 families; by 2000, according to the U.S. Census, there were 1,437 households. Despite the growth, the area continues to maintain its beautiful, tree-studded appearance. This 1937 shot looking north on El Camino Real at Jefferson Avenue directs people to the (as the area was known then) Emerald Lake district. (Reg McGovern.)

One of the most popular restaurants in Redwood City was the Fox Shoppe. Located at 432 El Camino Real, the Fox Shoppe's motto—"A little place that serves good food"—proved true when Duncan Hines and his wife, Florence, added the restaurant to their *Adventures in Good Eating* book. The Fox Shoppe was allowed to hang the prestigious "recommended by Duncan Hines" sign in their window. As with many great establishments, progress took its toll, and the restaurant was demolished in 1958. (Reg McGovern.)

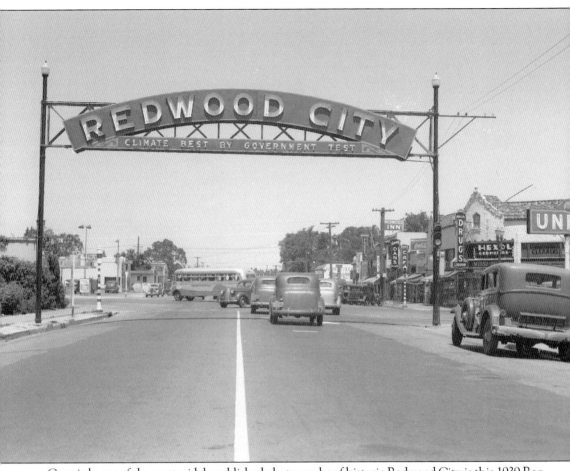

Certainly one of the most widely published photographs of historic Redwood City is this 1939 Reg McGovern photograph looking north on El Camino Real toward Broadway. Note the curtained windows in the Redwood City Bus Line's coach heading up Broadway past the Associated "Flying A" gas station and the architecture of Musso Drugs building, which today is Savada-Adamich Opticians. When El Camino Real was widened, the necessary real estate came from property owners on the west side (left in this photograph) of the street. (Reg McGovern.)

Two

DOWNTOWN
THE HEART OF THE CITY

Redwood City's downtown area is extremely unique. As the county seat, government operates side-by-side with industry, the arts, and, most visibly, retail commerce. In the early years, downtown functioned as a port and hub for the lumber and tannery industries. As the city grew, its focus changed to serving the consuming public with the expansion of retail and service businesses. The downtown also provided social gathering and entertainment spaces for the citizenry.

The county jail and courthouse have provided the backdrop for many historical and sometimes controversial legal battles. In the early months of 1955, a $2-million Hall of Justice was erected on the site of California Square. In later years, two of the most famous (or infamous) trials held at the Hall of Justice were those of Patty Hearst in 1975 and the 2004 trial of Scott Peterson.

Downtown was linked to the outside world by automobile, train, and ship, and in the late 1910s, the town's airport opened only a mile to the south. The city's slogan sign, "Climate Best by Government Test," has stood since 1925—first at Broadway and Winslow Street, then across El Camino Real at Broadway and Main Street, then El Camino at Claremont Street, and today at Broadway and Arguello and Maple Streets.

The Redwood City street scenes captured on these pages show life from the late 1930s through the 1960s. Shoppers bought baked goods at the Redwood Bakery and then went across the street to the Purity Store for perishables such as meat and produce. Dishes, linens, and toiletries were next door at Woolworth's or Sprouse-Reitz. Milk, eggs, cream, and butter were processed downtown and delivered fresh on doorsteps every other morning. Joseph Territo imagined having all of these products under one roof and hence opened Territo's grocery on Broadway.

Yet the most interesting aspect of downtown is how the area has grown and the number of original buildings that still survive. Aside from the original courthouse, the landmark Fox Theater could have been demolished years ago, but through people's vision and interest in preserving the city's heritage, there is now have a focal point on the renovated Courthouse Square. The buildings that were the city's first financial institutions and major retailers still stand. It is the mix of old and new that gives downtown Redwood City its unique character.

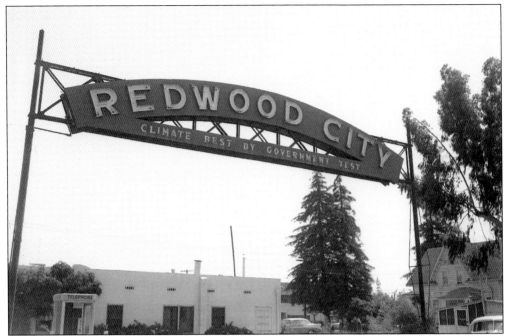

When El Camino Real was widened in 1947, the "Climate Best by Government Test" sign was moved near the city's northern border near Claremont Street, between the Fox Shoppe and the Standard Station. Drivers motoring from San Carlos into Redwood City were greeted by the Redwood City sign as they approached Whipple Avenue until 1970, when it was placed into storage. (Reg McGovern.)

The Flying A station on the corner of Broadway and El Camino Real, across from Sequoia High School, offered uniformed attendants who provided full service. In 1938, Associated Oil Company merged with Tidewater Petroleum, and the Flying A brand continued after the merger. In 1966, the western assets of Tidewater were purchased by Phillips Petroleum Company, which rebranded the Flying A stations to Phillips 66. (Reg McGovern.)

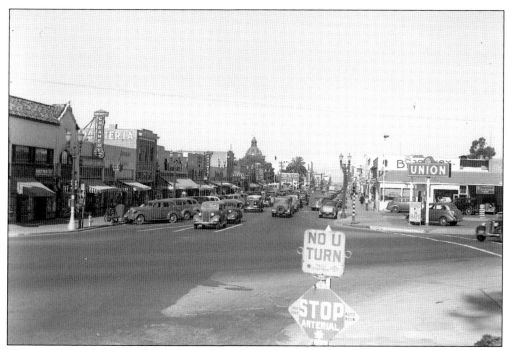

The view from the west side of El Camino Real down upper Broadway shows the thriving retail district of late-1930s downtown Redwood City. Business was so good there were three creameries on the north side of Broadway between El Camino Real and Arguello Street alone. The courthouse dome and annex can be seen in the distance in this 1939 view. (Reg McGovern.)

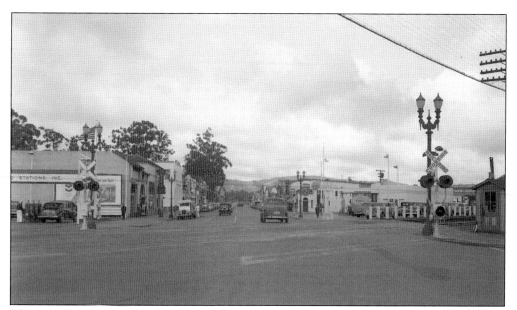

The opposite view looking from Arguello Street in downtown west to El Camino Real shows the upper Broadway business district packed with cars lining the curbs. Notice the undeveloped hillside in the background. (Reg McGovern.)

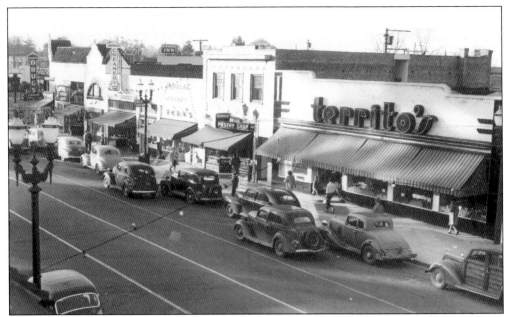

Joseph Territo opened his namesake market on Friday, September 1, 1933. The market, seen here on January 7, 1947, was finished in a green and black interior and featured a grocery and produce section as well as a deli and meat counter, which was a novel approach to selling groceries at a time when eggs, milk, and butter were home-delivered by the milkman. Coincidentally, before opening his own grocery, Territo was delicatessen manager at Popular Market, two doors to the west of his new, larger store. (Reg McGovern.)

Across the street from Territo's was 2625–2629 Broadway, home to a Purity Stores grocery, Western Auto Supply, and a Sprouse-Reitz variety store. Territo's would be stiff competition to both the grocery and variety store. (Reg McGovern.)

On the corner of Broadway and California Streets was the American Trust Company's Redwood City Office. Today 2529 Broadway is home to the A-1 Party Rental Center. (Reg McGovern.)

Lock Drugs was located on the corner of Broadway and Arguello Streets, and the building still stands. Nat Mangini and John Roselli acquired Lock Drug and grew the chain to five stores, adding locations in San Carlos, Belmont, Foster City, and Woodside. The Redwood City store featured a beauty parlor and soda fountain, which was a popular lunchtime haunt for workers from the courthouse. They reportedly had a table reserved for judges only. (Reg McGovern.)

Sequoia Laundry was a large employer in town. The company operated a laundry facility at 55 Perry Street, and its trucks were seen throughout Redwood City. (Reg McGovern.)

The F. W. Woolworth variety store was one of the first large chain stores to settle along Broadway. The discount store was located at 2403 Broadway on the corner of Hamilton Street. It is seen here in June 1937 preparing for its Father's Day sale. (Reg McGovern.)

Known as the Lathrop House, this stately home dates back to 1863 and sits at 627 Hamilton Street, in the heart of downtown. The home features 11 rooms, a kitchen, and maid's quarters. It was originally located on Broadway, where the Fox Theater is, but was moved to its present location in 1905 by Sheriff Joel Mansfield. It is seen here on March 2, 1956. (Reg McGovern.)

Montgomery Ward occupied 2317 Broadway between Winslow and Hamilton Streets. Regional shopping malls, such as Hillsdale and later Stanford, saw buying habits change, forcing large retailers to move from the downtown business districts to the malls by the mid-1960s. (Reg McGovern.)

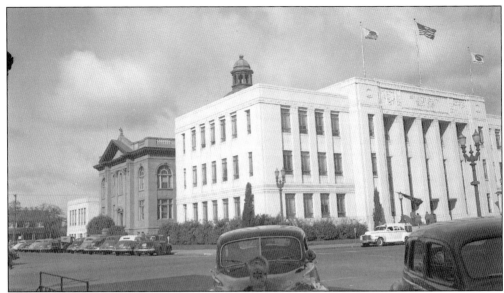

Built in the waning years of the Depression under the Works Project Administration, the courthouse annex, known as the Fiscal Building, was open for business in 1939. An annex building was added to the north side of the courthouse in 1940–1941. The Fiscal Building's last tenants—the county assessor, controller, and tax collector—moved out in 1998. Sitting relatively vacant in the ensuing years, the top floor was used to house the overflow of reporters for the Scott Peterson trial in 2004. The Fiscal Building was demolished in 2005 to make way for the Courthouse Square renovation project. (Reg McGovern.)

Shortly after the end of World War II, downtown Redwood City went through a revitalization effort. GIs were returning from war and were ready to resume stateside life, which would require setting up entirely new households. To meet this demand, many stores took the opportunity to remodel, including this J. C. Penney's location on the corner of Broadway and Hamilton Street. Feldman's Tire Store and the Kleer Drug Store were also under remodel at the same time. (Reg McGovern.)

Schneider's Men's Clothing began serving the peninsula in 1906. The men's department store opened its doors in Redwood City on Father's Day, June 15, 1954, at 2209 Broadway in the Fox Theater complex. The company had a nearly 90-year run as a San Francisco peninsula institution with stores in surrounding cities, including San Carlos and San Mateo. (Reg McGovern.)

Pacific Telephone and Telegraph's first Redwood City location was at 727 Middlefield Road in 1910, where three operators worked the day and one the night shift. In 1949, the company's offices moved here, to 830 Middlefield Road. By the early 1950s, telephone use had expanded greatly, and the company moved to a multistory building on El Camino Real and Winslow Street. By 1955, more than 10,000 calls a day were routed through the Redwood City office. (Reg McGovern.)

The San Mateo County Building and Loan Association was formed in 1890. Shortly after the April 18, 1906, earthquake, the Building and Loan Association moved to offices in the Barret-Fitzpatrick Building at 2022 Broadway, near Main Street. They were open for business and making loans by April 28, 1906. The Building and Loan Association closed in the mid-1960s. (Reg McGovern.)

On the corner of Main Street and Broadway sits the First National Bank of San Mateo County building. The bank was formed in 1891, making it the first commercial bank incorporated on the San Francisco Peninsula. The Renaissance-style building was designed by Alfred I. Coffey and was completed in 1900. It suffered heavy damage in the 1906 earthquake (see page 20). (Reg McGovern.)

Rudolph C. Holmquist emigrated with his family from Sweden in 1873. His father, Carl, worked at the Frank Tannery, while Rudolph began working for T. J. McNamara, a plumber who owned a hardware store on the west side of Main Street. After McNamara's death in 1895, Rudolph bought the business, then known as R. C. Holmquist Tinning and Plumbing. It suffered a fire in 1897 and was moved across the street. Rudolph retired in 1940, and his son H. E. "Rowdy" Holmquist took over. The business suffered another fire in 1956, and the store seen here at 875 Main Street, at Stambaugh Street, is the result of the rebuilding effort. Rowdy invested more than $500,000 to build this 24,000-square-foot hardware store that featured two levels and more than 267,000 individual items on its shelves. (Both, Reg McGovern.)

Main Street was home to both the Independent Order of Odd Fellows (IOOF), at 832 Main, and the Free and Accepted Masons of California, at 835 Main. Both buildings feature retail space on the ground floor with the fraternal group's meeting spaces above. After the 1906 earthquake, and with the county courthouse unusable, the IOOF hall served as San Mateo County's court with Judge George Buck presiding. In 1921, the facades of both buildings were redesigned by architect J. R. Miller. (Reg McGovern.)

Known as the William P. Jamieson Building, it also features retail on the ground floor and housing above. This space was the Redwood Groceria from 1920 to 1932, and Redwood Pharmacy occupied 901 Main Street from 1939 to 1962. A brick building was added to the rear facing Stambaugh Street around 1915. (Reg McGovern.)

In 1931, Burlingame auto dealers H. W. and W. J. Dessin expanded their enterprise to Redwood City. Their first location was at 865 Main Street, in the old Bell Theater, but that proved too small to show cars. The brothers purchased the property at 1101 Main and in 1931 erected this Gothic-style showroom that has 110 feet of frontage along Main Street. The property passed through a number of owners—Ferris Miles, West Bay Motors, Barnbauer Motors—but always remained a Dodge and Plymouth dealership. (Reg McGovern.)

Bank of America has had a long association with Redwood City. The bank's first branch was located on the corner of Broadway and Jefferson Avenue, seen here in 1937, and later moved to California and Winklebeck Streets before returning to downtown at 700 Jefferson Avenue. (Reg McGovern.)

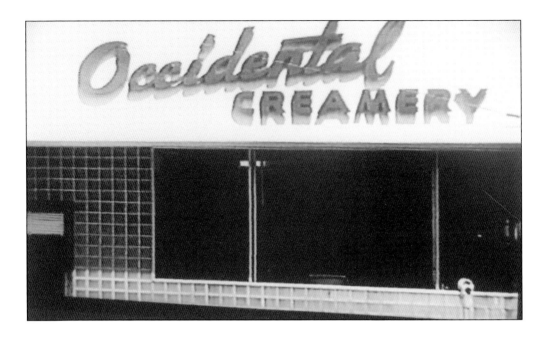

The Britschgi family owned and operated the Occidental Creamery on Jefferson Avenue. They would truck in raw milk from surrounding dairies and process it into products for home delivery. Public service ran in the family as well, with Carl "Ike" Britschgi serving in the state assembly and son Brent serving as a city council member and mayor, while Carl's brothers continued to run the family business. In the early 1990s, Brent Britschgi served as executive director for the Redwood City Downtown Association and led the effort to revitalize the area. (Both, Reg McGovern Collection.)

The southwest corner of Broadway and Jefferson Street became home to a 35,000-square-foot J. C. Penney's store. The retailer had occupied space two blocks away, at 2225 Broadway, and is seen shortly after its opening on May 1, 1952. A Thom McAn shoes and Singer Sewing Machine shop also shared space in the block. After nearly 30 years, Penney's moved out of the space in the early 1980s. Weinman's Furniture opened in the old Penney's building in 1984. Owned and operated by Manny Weinman, the furniture store did a thriving business through the 1990s. (Both, Reg McGovern.)

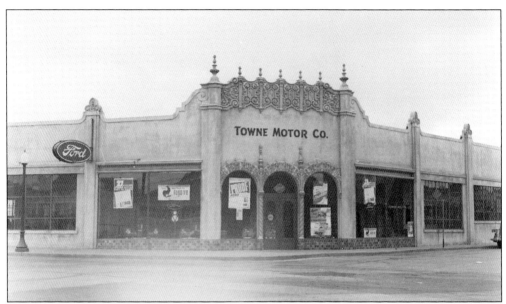

Towne Motor Company was located behind the Fox Theater on Middlefield Road. The photograph above shows the dealership's ornate late-1930s facade, while the photograph below depicts the building's clean, 1950s lines. Workers in the photograph below are picketing the dealership on May 13, 1954, and instead of carrying picket signs are wearing sashes over their suits to demonstrate their displeasure with management. The dealership later moved to the former Beeger Tannery property (see page 61) on the corner of Maple and El Camino Real. (Both, Reg McGovern.)

The city's first city hall stood on Middlefield Road between Main and Jefferson Streets. The second city hall complex was built on an adjacent parcel to the west, was dedicated on June 25, 1939, and included the city government's offices and a library. Funds for the construction came from the Works Project Administration. The civic center stood until 1995, when the buildings were torn down and rebuilt in the same location. (Reg McGovern.)

The Kaiser Permanente Medical Center selected a site on Veterans Boulevard between Walnut, Maple, and Marshall Streets for its new hospital and clinic complex. Construction is fairly well along in this November 28, 1967, view of the main hospital tower. In the late 1990s and early 21st century, Kaiser continued to expand, building a new parking structure and clinics on Veterans Boulevard. (Reg McGovern.)

This aerial view of downtown Redwood City, taken on July 20, 1949, shows the following: 1) Bayshore—Highway 101; 2) rodeo grounds; 3) Lock Drug Store, corner of Arguello Street and Broadway; 4) F. W. Woolworth Company, 2403 Broadway; 5) California Square, Marshall, Hamilton, and Winslow Streets; 6) Montgomery Ward, 2317 Broadway; 7) Hamilton Street; 8) courthouse, 2200 Broadway; 9) Middlefield Road; 10) Fox Theater, 2215 Broadway; 11) Pacific Telephone and Telegraph Company, 830 Middlefield Road; 12) Towne Ford, 700 block of Middlefield Road; 13)

J. C. Penney, Broadway and Jefferson Avenue; 14) Occidental Creamery, Jefferson Avenue; 15) PG&E Tank, Jefferson Avenue; 16) Bradford Street Drawbridge; 17) Sequoia Hotel, 800 Main Street at Broadway; 18) First National Bank of San Mateo County, Main Street and Broadway; 19) Masonic Hall, 835 Main Street; 20) Redwood Creek; 21) S. H. Frank Tannery; 22) U.S. Post Office, Jefferson Avenue; 23) city hall, 1017 Middlefield Road; 24) First Congregational Church, Middlefield Road and Jefferson Avenue; and 25) train station. (Reg McGovern.)

The Ampex Corporation was founded in nearby San Carlos in 1944, and one of its Redwood City assembly lines is seen in full production on February 18, 1957. By 1960, the company was expanding and turning out magnetic tape recorders at a prodigious rate. That same year, the firm hired its 2,000th worker, Rosemary Anderson, a 1952 graduate of Sequoia High. When Anderson was hired, Ampex still employed its first (founder Alex Poniatoff), 100th (F. S. "Bud" Moulton Jr.), and 1,000th (Bette McMahan) employees. (Reg McGovern.)

Three

A TOWN GROWS AROUND ITS INDUSTRY

Redwood City's tanneries were a by-product of the lumber industry, yet the tanneries outlasted the loggers by more than 60 years. On the heels of the sawmills and the growth in defense industries during World Wars I and II, a number of major industries settled in the flatlands of Redwood City.

California Body and Trailer Manufacturers at Spring and Chestnut Streets built truck bodies and buses; Johns-Manville, PABCO, Paraffine Companies, and Plant Rubber and Asbestos Works made forms of insulation, siding, and flooring for commercial and residential construction projects; Schwarz Engineering Company developed food processing equipment; S&W Fine Foods, Inc., was canning fruits and vegetables at its Heller and Laurel Streets cannery; National Motor Bearing was making seals and shims at Broadway and National Street; Benbow Manufacturing at Eleventh Street and Dumbarton Avenue was assembling guarded safety conductors for cranes and hoists; and at 901 Spring Street was the Chemical Process Company.

To support the city's growing population, a myriad of businesses and industries came to town to take advantage of its workforce and to sell its products. Bakeries, newspapers, utilities, food manufacturers, beverage distributors, and construction companies made Redwood City a boom town. From these payrolls, the city, county, and state collected taxes, which paid for roads—and a number needed to be built as the city grew in the 1940s and 1950s. Taxes also paid for police and fire services, and as evidenced in a number of photographs that follow, the Redwood City Fire Department earned its pay—often. There were a number of spectacular fires at the S. H. Frank Tannery, S&W Fine Foods, and Johns-Manville, to name three.

In the 1980s and 1990s, manufacturing and retail jobs in Redwood City began to dry up while employment in the service sector and the up-and-coming electronics business grew. The dot-com boom of the late 1990s and early 21st century cemented Redwood City's place in Silicon Valley with industry leaders such as Ampex and entrepreneurial companies such as Oracle, Electronic Arts, and other high technology companies. These companies provided job opportunities to people with a different skill set and those willing to take risks. For some, it paid off handsomely, while others, eXcite at Home for example, lost big.

During the past 80 years, Redwood City's industrial base changed—and for the better. The photographs that follow present a nostalgic look at those years of growth and change.

Originally formed as the Wentworth Tannery in 1872, the business was acquired by S. H. Frank in 1874, and it operated along the banks of Redwood Creek until 1959. The property was subsequently sold to a consortium of developers, including hotel magnate Benjamin Swig. On March 25, 1958, a donkey engine transports oak tree bark from Mendocino and Humboldt Counties from the receiving warehouse to the tannery. (Reg McGovern.)

Marcellino Cortez hangs hides for storage near the end of the tanning process. Each day, the S. H. Frank Tannery's 125 employees turned out 8,500 pounds of shoe sole leather, saddle leather, and harness leather. (Reg McGovern.)

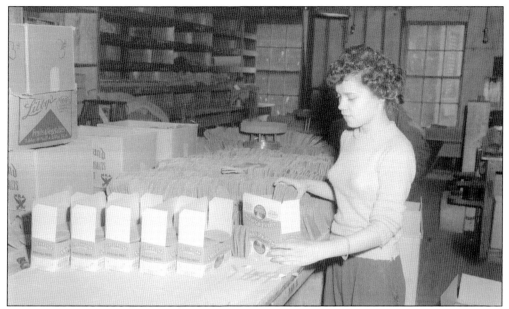

S. H. Frank Tannery's main product was shoe sole leather for men working in the logging and timber industry. Here a worker packs leather shoe top pieces that will be incorporated into workmen's boots by a cobbler. Approximately two dozen top pieces went into each box. (Reg McGovern.)

By 1957, the S. H. Frank Tannery was operated by a skeleton crew and was in its final days of operations. After 85 years of operations, the last tannery in town was closing. The State of California was busy constructing a new Highway 101 bypass, and the original Bayshore Highway can be seeing crossing the upper part of this photograph. The original Bayshore Highway became Veterans Boulevard, and Mervyn's Plaza now sits where the tannery was located. (Reg McGovern.)

Work to tear down buildings on the 18-acre S. H. Frank Tannery site began in July 1964. On the evening of June 13, 1968, the remaining buildings caught fire, which quickly spread, engulfing the entire tannery. Only the smokestack and water tower (at left) were standing when the sun rose on June 14. (Reg McGovern.)

One of the many local businesses in town was Walker Beverage. The beer distributor was initially located on Franklin Street, near the railroad tracks, but later moved to this site on lower Broadway. Here some of the company's employees pose for a promotional photograph. (Reg McGovern.)

Beeger Tannery was located at the corner of El Camino Real and Maple Street next to the Redwood Creek. Henry Beeger acquired the tannery in 1880, and upon his death in 1898, the business continued under his wife Mary's management. Subsequently, sons Carl and Henry Jr. ran the tannery, getting out of the business for good in 1947.

On October 18, 1949, the Beeger Tannery property was being converted for new tenants. Here the 50-foot-tall smokestack comes down, getting the attention of a worker on the right who has decided to move to safer ground. Fire chief Joseph L. Lodi was on hand to supervise the demolition. (Reg McGovern.)

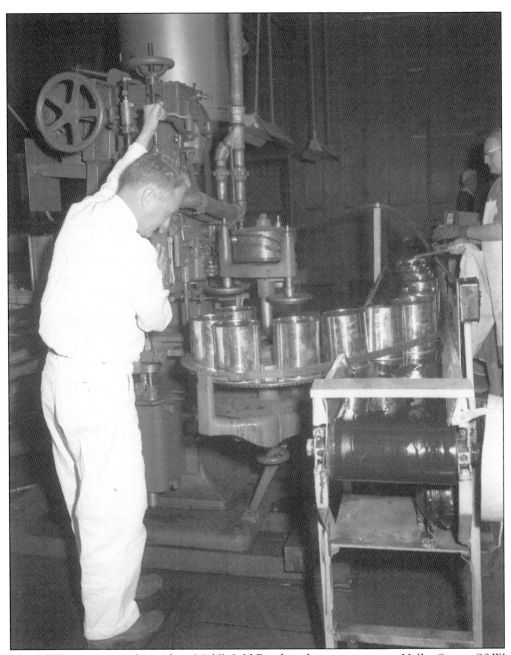

The S&W cannery was located on Middlefield Road, with its entrance on Heller Street. S&W acquired this factory from Pratt-Low in 1941. The cannery ran three shifts to meet production. On May 1, 1948, the day of this photograph, there was talk of expansion after the acquisition of additional parcels surrounding the factory. Here a worker prepares to seal large, No. 10 cans of fruit. (Reg McGovern.)

More than 300,000 square feet of the S&W cannery was under roofs. Here some of the more than 250 employees (550 during peak season) work handling the fruits and vegetables before they enter the production process. The cannery had an off-season payroll of $1 million. (Reg McGovern.)

An aerial ladder truck sprays water on the S&W cannery. The building caught fire and was heavily damaged in the early 1970s. (Reg McGovern.)

An aerial view of PABCO, makers of linoleum, paints, asbestos-based insulation, and asbestos cement shingle siding, dates from April 16, 1951. The company was located east of Bayshore Highway, off today's Seaport Boulevard in the same area as Lyngso. This PABCO location closed when the company opened a linoleum plant in New Jersey. (Reg McGovern.)

National Motor Bearing Company (National Seal Division) was founded by Lloyd A. Johnson and is seen on the morning of May 1, 1952. The company specialized in oil seals, grommets, gaskets, fiberglass ducts, and other intricate industrial items. On July 27, 1956, National Motor Bearing was acquired by Federal Mogul Bower Bearings, Inc. The acquisition of National Motor Bearing Company vaulted Federal Mogul Bower Bearings into the Fortune 500 (ranked at 350) with sales in excess of $100 million for 1956. (Reg McGovern.)

Asbestos was used to insulate areas in contact with high heat, in automobiles, and for use in residential and commercial construction. As common for the day, a worker at the Redwood City Johns-Manville plant wraps pipes with asbestos insulation without wearing gloves or a respirator. Note that the first work-related case of asbestos-related death was reported in 1906, more than 50 years before this photograph was taken. (Reg McGovern.)

Faulty wiring caused this $70,000 fire at the Johns-Manville factory on Middlefield Road on November 9, 1950. The company moved to Long Beach, California, and on May 7, 1957, the abandoned factory was burned to the ground under fire department supervision. (Reg McGovern.)

Plant Rubber and Asbestos Works made magnesia from bittern from 1933 to 1941. Magnesium hydroxide was mixed with soda ash, which produced magnesium carbonate that was used for thermal insulation. In succession, Plant Rubber and Asbestos Works, PABCO, and Johns-Manville all occupied the same Redwood City location. (Reg McGovern.)

On November 8, 1956, from left to right, co-owners Arlie Burns and Joseph Pisano and day supervisor Pete Del Bono watch as ingredients for bread loaves begin the mixing process at the new $150,000 Pisano Bakery on Maple Street at Bayshore. The bakery produced 35 varieties of breads and rolls, as well as a wide assortment of cakes and cookies. Pisano's employed 35 people. (Reg McGovern.)

Mrs. Jack Cromer, seen on February 12, 1957, holds one of the prize-winning chinchillas at her Top Hat Ranch, located at 757 Hillcrest Drive in the hills above Redwood City. Mrs. Cromer's animals won top honors at the World Show Championship. While the best of the best were kept for breeding purposes, the remainder were sold through the New York Fur Auction. It took approximately 20, and some times as many as 40, pelts to make a stole. (Reg McGovern.)

Ralph H. Ratliff owned Peninsula Garage, one of the city's largest tow services. Ratliff's tow trucks were often first on the scene at accidents, and in 1944, Redwood City police chief Mickey Collins suggested Ratliff add ambulance service to his business. In 1960, the ambulance service moved to a new facility, seen here, at 1260 Marshall Street. For most of the 1950s and 1960s, Peninsula Ambulance was the first responder to most medical emergencies in the county. (Michael Ratliff Lutz.)

The *Redwood City Tribune* was an award-winning, afternoon, daily newspaper that was founded in May 1923 and operated from this art deco–style building on the corner of California and Winklebeck Streets near the train station. The *Tribune* occupied this space until 1957. (Reg McGovern.)

Having outgrown its California Street home, the *Redwood City Tribune* began construction of a new facility at 901 Marshall Street in downtown in the fall of 1956. Occupied in August 1957, the 27,000-square-foot building housed the editorial and production staffs for the town's daily newspaper. In 1978, the Chicago Tribune Company bought the paper and merged it with the *Palo Alto Times*. The new, multicity paper was renamed the *Peninsula Times Tribune*. In 1989, the Marshall Street building was razed and replaced by two five-story office buildings. (Reg McGovern.)

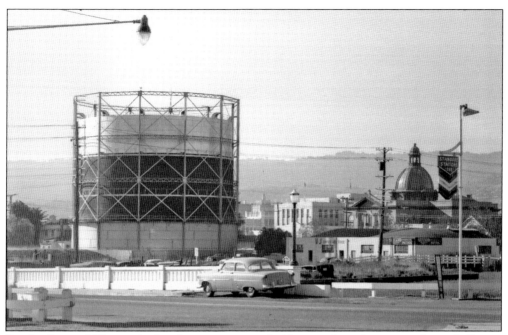

Pacific Gas and Electric built a low-pressure gas holding tank in downtown facing Jefferson Avenue, south of Bradford Street, in 1914. The tank was 100 feet tall and 100 feet in diameter and had a capacity of 500,000 cubic feet of gas. It dominated the city's skyline, and many a city council member worked diligently for its removal. On December 5, 1959, the utility announced its removal, and the city quickly announced plans to turn the property into a parking lot and to bridge the Redwood Creek to extend Marshall Street to Jefferson Avenue. (Reg McGovern.)

Ampex's new corporate headquarters are seen on December 5, 1969. The Ampex Corporation and its campus are still located on Broadway, and the company is still in the electronic imaging and data gathering business. The company has won 11 Emmys and one Oscar for its technical achievements. (Reg McGovern.)

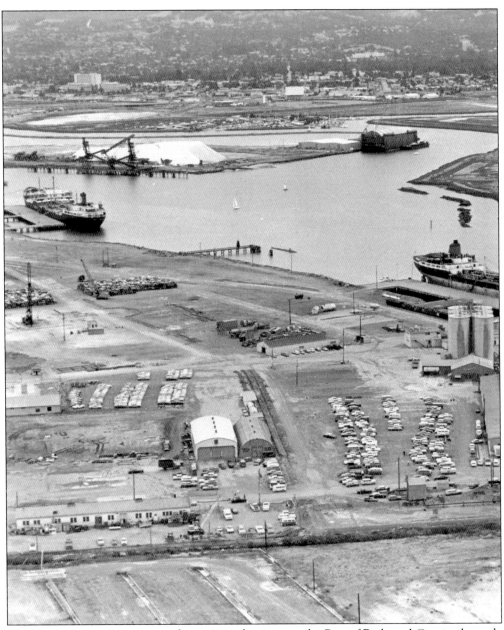

This dramatic air view captures the variety of activity at the Port of Redwood City in the early 1970s. Two oil tankers are waiting to be discharged, and the original Wharf 1 can be see on the right. In May 1972, a mysterious vessel called the Hughes Mining Barge (upper right) began to be built near the Leslie Salt stack. The 30,000-square-foot, 100-foot-tall vessel was to be constructed for Hughes Tool Company as a submersible dry dock for use in undersea mining, which turned out to be a cover story as the barge was used to recover a sunken Soviet submarine from 17,000 feet below the surface of the Pacific Ocean in 1974. (Reg McGovern.)

Four

PORT OF REDWOOD CITY
PROVIDING JOBS AND COMMERCE

From its earliest days, Redwood City's extensive waterfront has been one of its greatest natural assets, a catalyst in the development of the city as well as a recreational resource enjoyed through generations. Situated at the end of a deepwater inlet to San Francisco Bay, Redwood City's ideal location attracted pioneering entrepreneurs. After its initial discovery in 1851, Redwood Creek began to be used first by lumber companies and then other industries to transport goods to San Francisco. By 1935, citizen and governmental support united behind the dredging and other needed improvements for the Port of Redwood City, which opened in 1937. Building materials and bulk commodities have remained this port's mainstay, including the lumber that created thousands of Bay Area homes, cement, gypsum, leather, agricultural goods, recycled metal, bunker fuel, and more. Port-based industries, including Pacific-Portland Cement Company and Permanente Cement, contributed to the city's employment base. For decades, Leslie Salt Company farmed saltwater ponds along the bay, and the salt stack was as much a Redwood City landmark as the Easter Cross or the courthouse dome.

The port has also served in wartime and was taken over by the U.S. Navy during World War II. Some 125 ships docked and two million barrels of gasoline were shipped to overseas points, the *Redwood City Tribune* reported at war's end. During the Vietnam War, napalm shipments brought protests to the port. In 1972, the famed Hughes Mining Barge owned by the reclusive billionaire settled into secrecy along the Redwood City harbor.

The waterfront has inspired a wide variety of recreational projects and pursuits, from sailing lessons to collegiate crew racing. In addition to the municipal yacht harbor, boaters have berthed at several Redwood City marinas, including Docktown, the Peninsula Marina, and the late Pete Uccelli's "Pete's Harbor." The same inlets and sloughs that bird watchers prize today were once duck-hunting territory. Marine World Africa USA's two-decade-run in Redwood City entertained countless visitors and provided many local kids their first jobs. Redwood City's waterfront expanded exponentially in 1959, when the future Redwood Shores area two miles north of the city proper was annexed, following rejections by San Carlos and Belmont. Over the years, a planned development with thousands of homes and millions of square feet of offices and commercial space has risen on former baylands, with homes for corporations such as Oracle Corporation, Electronic Arts, and other high-tech firms.

In 1926, private interests tried to develop "Port San Francisco" at Belmont, even dredging the harbor for it. Backers predicted the Belmont port would attract thousands of workers and "create a new era of progress and prosperity." But it was not to be. Vestiges of the old turning basin remain as part of the Redwood Shores lagoon. Redwood City, on the other hand, forged ahead, obtaining critical federal dredging funds in 1935. (Reg McGovern.)

Lumber was one of the main commodities crossing the docks in the early days of the Port of Redwood City. The *Davenport* was a frequent visitor, bringing lumber down from the Pacific Northwest to the port, where the building boom on the peninsula was under way. The teenaged Reg McGovern took this and other photographs at the port in the late 1930s at the behest of port manager Walter Murphy. (Reg McGovern.)

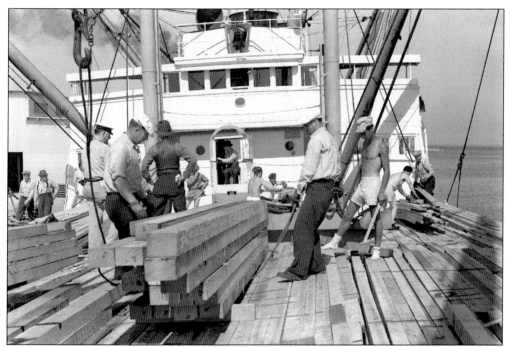

Stevedores on a lumber schooner unloaded deckloads at the Port of Redwood City in the late 1930s. On the right, shirtless, is Dave Belasco, then a local teenager, who got some pointers on longshoreman's work. (Reg McGovern.)

Port employee Jim Rice drove a lumber-carrier, a special vehicle used forklift-style to lift lumber off the wharves that had been stacked by longshoremen. The wharf and the lumber schooner are visible in the background of this photograph. From 1938 to 1940, an average of two lumber carriers a week called at the port. (Reg McGovern.)

A late-1940s aerial view of the Pacific Portland Cement Company shows the tremendous level of activity at this important industry on the Redwood City waterfront, which was served by the Southern Pacific industrial spur. In the foreground are the large cement storage silos; near the bay, shell unloading cranes scooped shells and mud out of the barges for manufacture into cement. (Reg McGovern.)

Cement dredges loaded seashells from the bay bottom onto barges that were transported to Pacific Portland Cement Company. At the mill, a mixture of the shell deposits and clay went through the treatment and chemical process to produce premium-quality cement. (Reg McGovern.)

George Tavalero tended to one of the large kilns used in the manufacturing process at the Pacific Portland Company cement plant at the port. Pacific Portland began its Redwood City operation in 1924 and merged with Ideal Cement Company in 1952. (Reg McGovern.)

A line of Grifall Brothers trucks waited to receive offloaded gypsum from a Kaiser Permanente ship docked at the Port of Redwood City in 1947. (Reg McGovern.)

For many years, Pete Uccelli operated Pete's Harbor, a successful and popular restaurant and marina business along the waterfront, seen from this late-1960s aerial view. The Leslie Salt pile is in the background, and the Lockheed research buildings are to its left. (Reg McGovern.)

This 1955 aerial view shows the original yacht harbor with a ship at the salt dock on the left. Much of the bare land in the photograph is currently occupied by the Portside Business Park, and today's Seaport Boulevard is the road at the top of the photograph. (Reg McGovern.)

For decades, crews harvested industrial salt from South Bay salt crystallizer ponds operated by Leslie Salt Company. During salt harvesting "season," Leslie used tiny rail cars that traveled along portable railroad tracks collecting the crusty salt. Salt was stockpiled in a giant glittering white pyramid near the Port of Redwood City, and bulldozers regularly manicured the mountain of salt deposited by belt-feeders. The salt was then shipped to customers from a 460-foot-long loading dock. Leslie Salt was purchased in 1978 by Cargill, but salt continued to be produced under the Leslie label until 2003. The same year, Cargill sold the landmark docking and loading facility at Redwood City. (Both, Reg McGovern.)

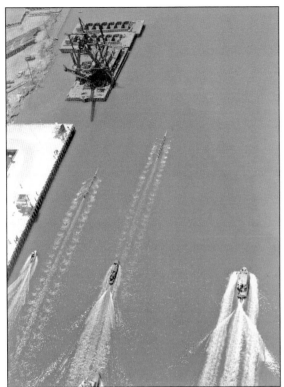

The Redwood City waterfront has always offered abundant recreational opportunities, among them the annual crew races at the port. The Stanford varsity team (on the right in this June 1955 contest) poured it on over the three-mile course and beat the University of California Bears for the first time since 1917. Some 3,500 onlookers turned out to enjoy the waterfront races. The races were later relocated to Redwood Shores. (Reg McGovern.)

The Ohio Building was built for the 1915 International Exposition in San Francisco and was modeled after the Ohio State Capitol. After the expo, a promoter named Woolsley had grandiose plans to barge it down the bay and create a yacht harbor and playground for the Peninsula Country Club. In 1916, he managed to get the building moved to piers at Steinberger Slough, in today's Redwood Shores. Woolsley did not have the funds to realize his dreams, and the building sat vacant until the early years of Prohibition, when the building was a nightclub and bootlegging hideaway. In the 1930s and 1940s, the once-ornate structure housed a machine shop for aviation enthusiasts Will and Charley Cooley, who manufactured radar equipment. (Both, Reg McGovern.)

A contractor who purchased the Ohio Building in 1953 from the heirs of the Cooley brothers decided to clear the site for an asphalt plant. An estimated 1,500 people came from miles around, some traipsing through the marshland, to see the one-time "Queen of the Mudflats" burn to the ground October 14, 1956. (Reg McGovern.)

The 1,500-acre area known as Redwood Shores was annexed into Redwood City in 1959 and over several decades has been developed as a master-planned community. This 1969 air view looking north shows the initial stages of progress as the first subdivisions went in and Bridge Parkway had yet to be built. The small round building to the left was the developer's marketing office, and Marine World can be seen at the top. (Reg McGovern.)

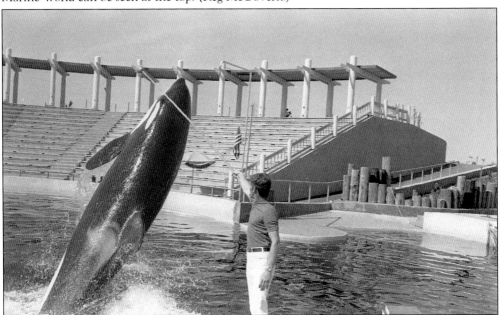

Head trainer Sonny Allen put Kianu, a five-ton killer whale, through its paces for the cameras in March 1969 as Marine World prepared to open for a second year. The park's general manager bragged that the aquatic park was "the greatest show on H-2-0." The amusement park, which subsequently added "Africa/USA" to its name, relocated in 1986 to Vallejo. Oracle Corporation now occupies the old Marine World site at Redwood Shores. (Reg McGovern.)

Located at what used to be the far reaches of the Redwood Shores baylands, KGEI was a tiny shortwave facility owned by General Electric Company, broadcasting to Asia during World War II when the Office of War Information took over programming. After the war, GE asked Stanford University professor Ronald Hilton to create a "University of the Air," broadcasting to Latin America. The station is now the home of Fully Alive Community Church. (Reg McGovern.)

The *Sea Shadow* (IX 529), seen cruising San Francisco Bay, is a stealth ship that was built by Lockheed-Martin in secret in Redwood City inside the Hughes Mining Barge. A joint program funded by the Advanced Research Projects Agency and the navy, *Sea Shadow* was used as a proof-of-concept ship to test ship control, structures, and radar cross-section measurements. *Sea Shadow* was 164 feet long and 68 feet in beam with a draft of 14.5 feet, and it was operated by a crew of 10. As of 2008, *Sea Shadow* and the Hughes Mining Barge were stored in the reserve fleet at Suisun Bay, California. (U.S. Navy.)

This magnificent building was the Redwood City Public School, which stood on Broadway between Middlefield Road and Hamilton Street, opposite the county courthouse. Built in 1895, the school housed elementary students on the lower floors and high school students upstairs until a new high school was built in 1904. It was demolished in 1928 to make way for the Sequoia Theater's (later the Fox Theater) construction. (Veronico Collection.)

Just two years after the first Sequoia High School building was constructed, it suffered major damage in the 1906 earthquake. The community rallied, and money was raised to repair the damaged school. After Sequoia's present campus opened in 1924, the old high school served as an elementary school until 1948. (McGovern Collection.)

Five

COMMUNITY INVOLVEMENT
EDUCATION, WORSHIP, AND ACTIVITIES

From its beginnings as the oldest incorporated city in San Mateo County, Redwood City's definition of itself has always seemed to call for superlatives: there's the "Climate *Best*" motto, of course, but Redwood City boasts many "firsts," "oldests," and other toppers. There's the first Protestant church in the county and first public high school on the peninsula. The Easter Cross, high above the city, is the only such landmark from the peninsula to San Francisco's Mount Davidson. In 1992, Redwood City won the first Library of the Year award in the nation. Over the generations, Redwood City residents have enriched their educational, religious, and community institutions. Sequoia High School created a model educational program that offered a solid academic grounding, as well as music, arts, and vocational instruction. Its sports department produced outstanding athletes and a wide range of team sports. Sequoia's architecture and landscaping gave the campus an almost collegiate feel. Here is another superlative: the school is one of Redwood City's nine National Register of Historic Places listings. Residents have historically seemed to be among the paradingest people on the planet, gathering for Memorial Day parades, for Christmas, to celebrate downtown construction progress—or just to watch children wheel their bikes by. From the earliest days, fun-loving patriots mustered parades for the Fourth of July. In 1939, the group that later became known as the Peninsula Celebration Association (PCA) got its start. For decades, the PCA organized an Independence Day extravaganza that included a Wild West Rodeo, concessions, rides, fireworks—and parades that attracted some of the best marching bands in Northern California. The wide variety and range of activities have made Redwood City ideal for bringing up children. During the summers, the Sequoia swimming pool or the annual Soapbox Derby races beckoned. Musically inclined students learned under Sequoia instructors such as Otis Carrington, Max Gelber, or Jay Selby; athletes trained with coaches like Joe Marvin, Len Casanova, Al Terremere, Clyde Devine, Ray Dimick, and Bob Whitmore. Physical education director Frank Griffin set a standard for the team sports program that was a model for other high schools. The list of stellar teachers and activities that have made Redwood City what it is could go on and on. As a matter of fact, it does because the city's residents today are embellishing the definition of a great hometown with their own additions.

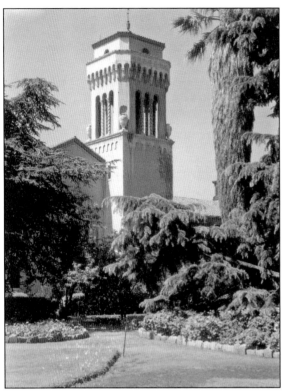

The campanile (bell tower) at the entrance to Sequoia High School was constructed in 1923 as part of the main building. It is known as Argo Tower in honor of Clarence Argo, the visionary principal from 1921 to 1948 who established exemplary academic and extracurricular programs that made Sequoia a model high school in the state. (Cumming Collection.)

Sequoia High School, built in the Spanish Colonial Revival style, opened in 1924 on the site of a former 40-acre estate at Broadway and El Camino Real. The original cement benches and landscaping, including a Japanese tea garden, recalled the estate's past. The dramatic front gates, built in 1924–1925, were replaced in the 1940s when El Camino Real was widened. The school is on the National Register of Historic Places. (Keith Cole Studio/Cumming Collection.)

The 1891 opening of Stanford University spurred interest in a southern San Mateo County high school to prepare students for college. The first public high school on the peninsula, Sequoia High School, opened in 1895, holding classes in the public school. A new school, on Broadway, opened in 1904 and served until enrollment growth prompted a search for a new site. This is the 1913 graduating class. (Cumming Collection.)

Lincoln School was one of the first schools in Redwood City, built in 1916, the same year as Washington School. Located at Whipple Avenue and Oakdale Street, Lincoln School educated generations of Redwood City youngsters until the decision was made to close it in 1975 because of declining enrollment. Washington School closed four years later. (Reg McGovern.)

State Assemblyman, and later senator, Horace Hawes, who wrote legislation that established San Mateo County, once owned vast Redwood City acreage, including Eagle Hill, a knoll he envisioned for "Mount Eagle University." His dream for the site overlooking Jefferson Avenue was not to be, and a French-provincial-style school was created in its place. John Gill School was named in honor of the beloved school superintendent after his untimely death in 1937. (Reg McGovern.)

The 1938 Sequoia High School football team is flanked on the far left by coach Al Terremere, for whom the football field was named. He later became principal of Carlmont High School. Assistant coach Clyde Devine (far right) was a well-known athlete and swimmer who was a member of Billy Rose's Aquacade at the International Exposition in 1939. Devine later owned a diving school. (Reg McGovern.)

Sequoia High School's 1935 varsity basketball squad featured, from left to right, (first row) Tom Graham, Jack Estes, and Jose Vaseli; (second row) Dave Brodie, Fred Duttweiler, Marston Gerard, Tony Ladesma, Charles Guinasso, Ed Mariani, and Jack Baxter. (Reg McGovern.)

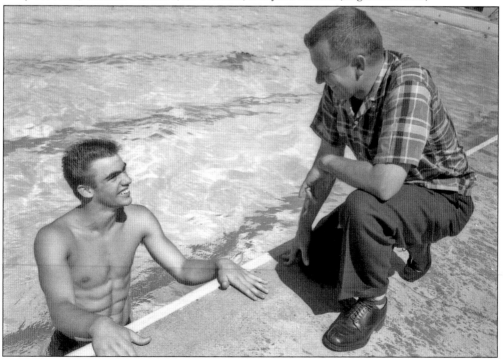

Among many swimming records, as a sophomore, Sequoia High School swimmer Marty Hull held the national record in the 100-yard breaststroke when he was named the *Redwood City Tribune*'s first Sequoia District Athlete of the Year in 1959. Both Marty and his brother Steve were outstanding swimmers who later became dentists in Redwood City. Marty is pictured here with swim coach Bob Whitmore. (Reg McGovern.)

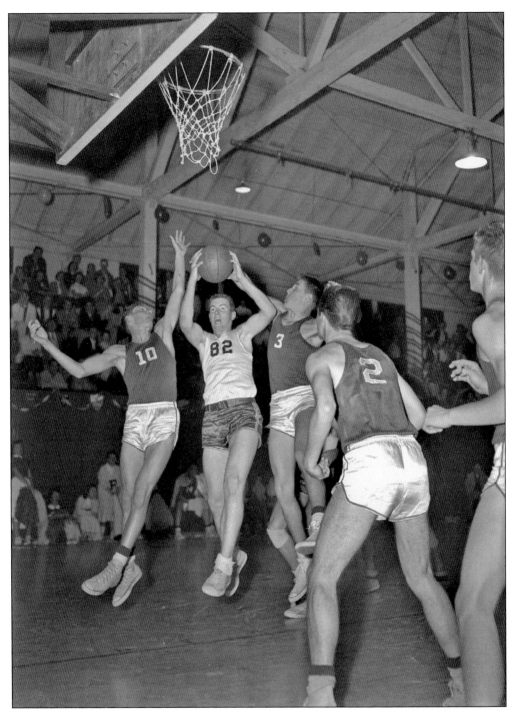

Sequoians and their coach Ray Dimick competed on the basketball courts with South Peninsula Athletic League teams from as far away as San Jose. But there was a particular quality to the enduring rivalry with the Palo Alto High School Vikings. In this 1956 season finale, Sequoia's Duke Stroud (82) grabbed the ball on the rebound from Paly's Jerry Collins (10), but the Vikings prevailed nonetheless. (Reg McGovern.)

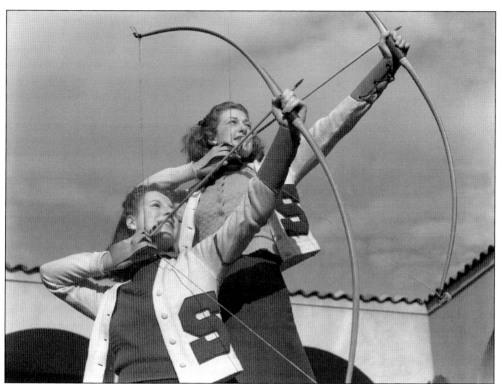

Sequoia High School's excellent physical education program set a standard for other schools to emulate. The wide range of Cherokee sports offerings included activities for both boys and girls, such as these members of the girls' archery team who struck a photogenic pose with their bows and arrows. (Reg McGovern.)

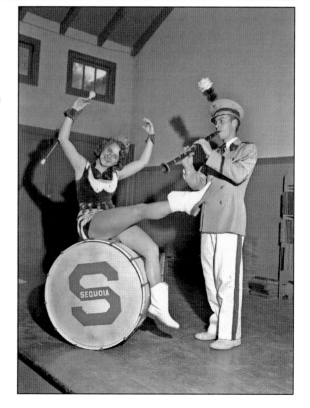

Drum majorette Natalie Fancher and band captain Pete Main on clarinet tuned up for an upcoming appearance by the Cherokee Band at an East-West Shrine Game at Kezar Stadium. Participation was by invitation only, but Sequoia had been invited for five of the six years since Robert Smith had become its director. (Reg McGovern.)

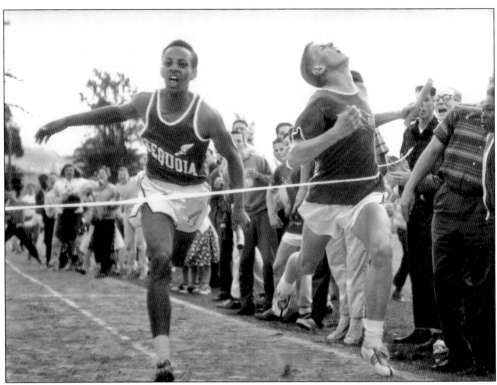

Johnny Miller, a track star at Sequoia, is pictured here in a tight finish at one of the many hotly contested track meets that the school participated in. (Reg McGovern.)

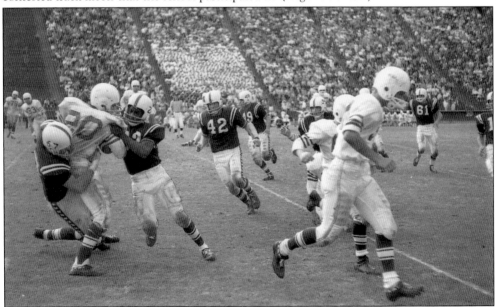

For many years, Sequoia and Palo Alto High School faced off at Stanford Stadium on Thanksgiving Day for the "Little Big Game." Upwards of 13,000 ardent fans filled the stadium for the November 23, 1961, Cherokee-Viking clash. Two touchdowns in the second half gave Sequoia (in dark jerseys) its 29th consecutive victory and third straight unbeaten season. (Reg McGovern.)

Sequoia High School's Treble Clef singers, under the direction of Robert Clark, sang "Beautiful Sequoia" during a 1957 tree-planting ceremony in honor of Otis Carrington. Carrington, pictured with his wife at right center, had been a member of the faculty for 40 years and wrote the school song. Next to the Carringtons at the Arbor Day event are San Mateo County supervisor William Werder, left, and Sequoia physical education director Frank Griffin. (Reg McGovern.)

Redwood City was big on parades, and Fourth of July was one of the city's biggest celebrations. The Sequoia High School Band was one of the state's best and was invited to many civic events. Here the band marches down Broadway during the 1951 Fourth of July parade. Note the Walgreens drugstore on the corner of Hamilton Street and Broadway in the Fox Theater building. (Reg McGovern.)

Sequoia students swayed to Big Band tunes during one of the many noontime sock hops like this one in the late 1930s, held in the girl's gymnasium. Night dances such as the school prom were much more formal occasions. (Reg McGovern.)

Sequoia High School graduations like this one in June 1957 were dignified, formal occasions marking an important transition in life. These events were held in a tree-studded recreation area of the campus with permanent platforms where the graduates sat. The school orchestra performed as the students marched down the aisle, and the a cappella choir, the Treble Clef, sang. (Reg McGovern.)

Some things never change: with a summer of fun ahead of them, joyous third-graders at Garfield School reacted about like they do today when the school year ended in 1957. Garfield was one of 17 elementary and junior high schools in the growing district, including Roy Cloud Elementary School, which opened that year. (Reg McGovern.)

Parents in the 1950s were understandably concerned about the spread of the paralyzing disease polio, and Dr. Jonas Salk's breakthrough vaccine made him a national hero. The vaccine was rushed into production in 1955 and became available in Redwood City in June. Parents lined up out the door of the clinics at schools like Henry Ford School so their children could get their polio shots. Dr. Francis Howard is pictured giving a shot. (Reg McGovern.)

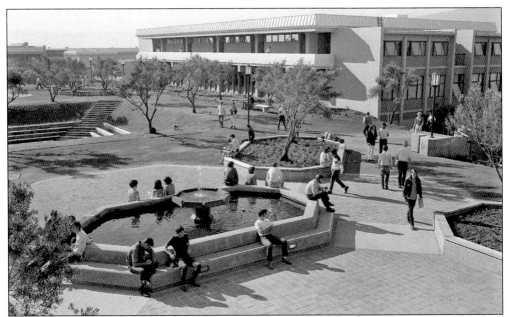

Cañada College opened in 1968 on 131 acres in the hills of Redwood City, at 4200 Farm Hill Boulevard. One of three two-year institutions in the San Mateo County Community College District, Cañada College added a University Center to its offerings in 2001 where students can earn a bachelor's degree in several fields. (Reg McGovern.)

The First Congregational Church, the first Protestant church in San Mateo County, was formed by 12 pioneers who first held services in an upper room at the courthouse. The church was formally organized in 1862, and its first building was located at Middlefield Road and Jefferson Avenue. In 1957, the congregation dedicated a new sanctuary for the "Church on the Rock" built around a huge rock outcropping at McGarvey and Euclid Avenues. (Reg McGovern.)

A Baptist missionary and eight members organized the First Baptist Church in 1868. Membership rose to 22 by 1872, and the first church building, a structure that cost $5,000, was dedicated in 1874. In 1930, the church moved from its 402 Heller Street location to a new site at Hudson Street and James Avenue, which was expanded several times in subsequent years. (Reg McGovern.)

Our Lady of Mount Carmel Church was originally built in 1886 at El Camino Real and Brewster Street and in early days was called St. Mary's. The parish school on Brewster Avenue was founded in 1885 but did not take on the Mount Carmel name until 1922. The school relocated to Katherine Avenue and Grand Street in 1932, and the school auditorium was used for services until the current building was completed in 1952. (Reg McGovern.)

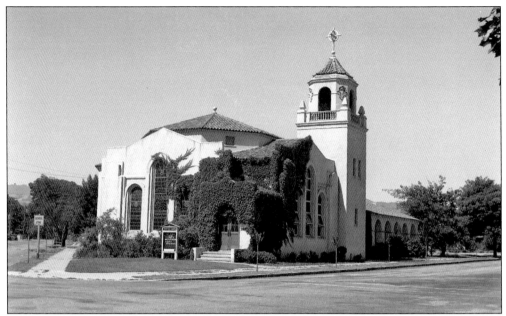

A town with a growing population soon welcomed additional churches, including the First United Methodist Church in 1864 on Main Street. A second church was built on Maple Street in 1872. After long preparation, the congregation moved in 1925 to the present site at Broadway and Brewster Avenue. Later it was enlarged, and a carillon was purchased in the early 1960s. (Reg McGovern.)

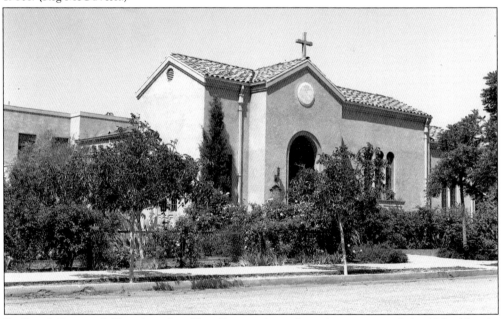

St. Peter's Episcopal Church is the oldest Episcopal parish in the county and the 11th oldest in the state. The Reverend Giles A. Easton led the first service in the county courthouse in 1864, and three years later, a new church building was consecrated. The parish moved to its present site at Clinton Street and Brewster Avenue in 1926. Final expansion of the current church, built in 1952, was completed in 1962. (Reg McGovern.)

The St. Pius parish was established in 1951, when the Mount Carmel parish divided. Construction of the new church and first school building at 1100 Woodside Road were nearing completion in February 1953, when this photograph was taken. Built on an eight-acre lot, the church had a stucco exterior and was designed to seat 750. The cost was estimated at more than $500,000. (Reg McGovern.)

The original Easter Cross was erected in 1929, welcoming worshippers for decades for sunrise services like this one in 1956. The cross went dark in 1941 because of the World War II blackout, but in April 1946, some 2,000 people attended the first postwar Easter sunrise service. After the original cross was vandalized in 1960, the community raised money to replace it in 1962 with the concrete cross on California Way that remains a landmark today. (Reg McGovern.)

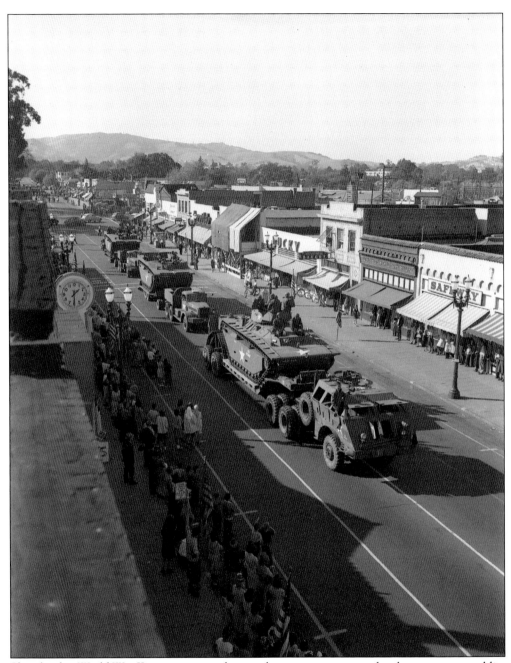

Shortly after World War II came to a conclusion, the army went out to thank a war-weary public. On the home front, Americans were forced to conserve resources through gas and food rationing, and recycle rubber and metal for the war effort. On November 3, 1945, the Victory War Loan Parade came to Redwood City, with troops, a military band, and amphibious tanks on flatbed trucks moving through the streets of downtown. (Reg McGovern.)

Redwood City's Fourth of July parade was a colorful spectacle featuring some of the best marching bands in Northern California, as well as floats, horse units, military vehicles, twirlers, and the rodeo queen and her court. Thousands of spectators jammed downtown streets to view the parade, which officially opened the celebration. (Reg McGovern.)

The rodeo had been held in various locations, including on Vera Avenue, before moving to the Bayshore Highway and Broadway site in 1947. Huge crowds overflowed the rodeo grounds. The old Bayshore (now Veterans Boulevard) is on the left and National Motor Bearing Company is at the top. In 1950, the Peninsula Celebration Association purchased acreage east of Veterans and north of Brewster Avenue and relocated yet again. (Reg McGovern.)

Had someone been on the Ferris wheel on July 4, 1948, this is what he would have seen: more than 10,000 people crowding the rodeo grounds to witness riding events and participate in the playland activities. (Reg McGovern.)

100

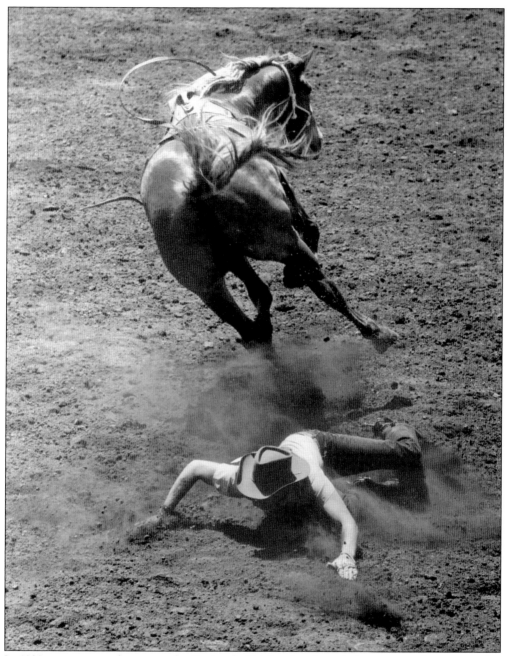

In 1939, a group, now known as the Peninsula Celebration Association, got together to organize Independence Day activities. Redwood City's celebrations extended over three or four days and included a rodeo and Wild West show featuring trick-riding, Brahman bull riding, bulldogging, and trick-roping. Kids and adults could spend the day at an adjacent playland offering rides, hotdog stands, and games of chance—and then stay up to watch two nights of fireworks. (Reg McGovern.)

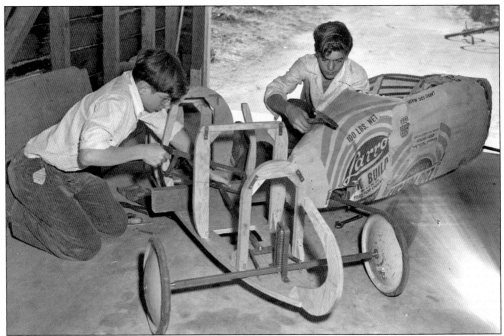

Several thousand people lined Katherine Avenue between Jeter and Nevada Streets for the 1947 Redwood City Soapbox Derby. Sponsored by Davies Auto Company, the Redwood City Kiwanis Club, and the *Redwood City Tribune*, the local derbies were a preliminary to regional and national events. The races were open to boys ages 11 to 15, and the coasters had to meet strict qualifying rules, with a total weight of car and driver not to exceed 135 pounds. Twenty-three boys competed in July 1947 when these photographs were taken, which show brothers Joe and Phil Spinella getting ready for the big day. (Both, Reg McGovern.)

More than 200 local youngsters rode their colorfully decorated bikes through downtown Redwood City in June 1948 for a bike safety parade. Each child received a set of 12 safety rules. Throngs of interested parents and onlookers lined the sidewalks to look at the bikes. Judges, who had to select the "best and most beautifully decorated bikes," awarded first prize to Joan Treher, whose bike was festooned Polynesian-style. (Reg McGovern.)

The city once sponsored its own Redwood City Municipal Band, led by Dr. Lee Otis. The group first performed in 1937 for the opening of the port and later in parades from San Francisco to San Jose. At its peak, the roster included some 50 musicians, but World War II "disbanded" the band. In 1949, the city auctioned off the remaining instruments and uniforms, displayed by city clerk Ralph Dodge. (Reg McGovern.)

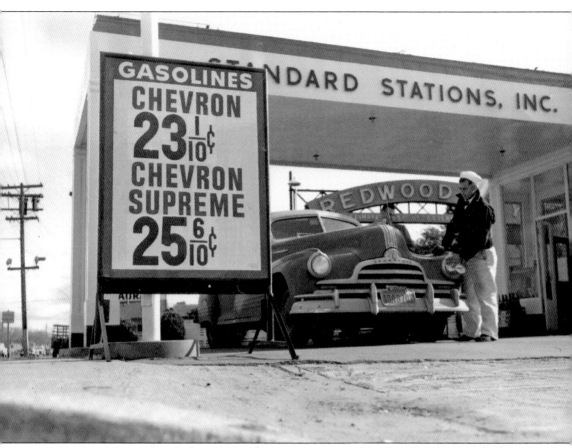

A gas price war raged in the late 1940s, when service stations like this Chevron Standard station on El Camino Real at Claremont Street were lowering gas prices by 1 or 2.5¢ a gallon. Company stations had started the price war to combat self-service stations and some of the independents quickly followed suit. Redwood City's landmark "Climate Best" sign is visible in the background. (Reg McGovern.)

Six

AROUND TOWN

Through the years, Redwood City has continued to grow from its humble beginnings as a logging town to its current population of approximately 76,000 (2005 census). The city covers approximately 19 square miles. Four major arteries run through Redwood City: Highway 101, Highway 280, U.S. Route 82 (El Camino Real), and U.S. Route 84 (Woodside Road). The Woodside Road corridor runs east from Highway 101, west past Highway 280, and continues into the Woodside hills. This corridor has seen logging wagons in the early days and lodges and taverns for weary travelers at Five Points, has been a major contributor to agriculture with its greenhouses and flower production, and today has a prosperous retail trade all along the corridor, focusing on Woodside Plaza. Aside from automobile transportation, the city is served by Caltrain, which moves commuters both into and out of the city. The city's bus routes supply alternatives to driving, making a car-less commute an alternative for many residents. From the days of the Civil War, Redwood City has been home to the Union Cemetery, located on Woodside Road just west of El Camino Real. A tremendous restoration and preservation effort has been under way to return this sacred ground to its former glory. A stroll along the Union Cemetery's tree-lined paths is a history lesson through time. Redwood City has also housed the training facility for the San Francisco 49ers, is the site of a California National Guard Armory, and provides a number of housing subdivisions, from beautiful old c. 1900 homes to modern condominiums. From its beginnings to the current day, Redwood City continues to thrive and attract diverse people and businesses to the community. This chapter's selection of photographs presents a glimpse of the city before many of the major changes of the 1960s and 1970s, the need for change, and some of the people who have impacted our community.

Completed in 1908, this Craftsman bungalow was one of the first homes built in the Dingee Park subdivision. It is located at 1816 Hopkins Avenue and was constructed for Richard Schmidt Jr., a lithographer in San Francisco, with his uncle Max Schmidt at M. Schmidt and Company, also known as the Schmidt Lithography Company. The Schmidt Company was the largest lithography company on the West Coast and once owned the clock tower building at Second and Bryant Streets in San Francisco. (Redwood City Library.)

Located in the Dingee Park neighborhood at 2004 Hopkins Avenue, on the northwest corner of Jeter Street, is the home built for Clarence and Maude Hayward. The home was built in 1910, and was a large version of the popular bungalow style with Tudor Revival–style elements. Originally a successful lumberman in Pescadero, Clarence Hayward entered politics and became county assessor. (Redwood City Library.)

Opening in 1910, the Redwood City Hospital was located at the corner of Phelps Street (now Middlefield Road) and Spruce Street. The hospital was owned and operated by registered nurse Mabel Hulings, shown on the left, and her mother, Mary Hulings. In 1921, a group of nurses from San Francisco purchased the facility. In the early 1940s, it was converted to a rest home until its closure and demolition in the mid-1950s when the Woodside over-crossing was built. (Redwood City Library.)

Downtown shoppers were served by a Safeway grocery store on Arch Street, between Brewster Avenue and Broadway, beginning in the mid-1930s. The end for this store came shortly after the grocery chain opened a new store at 2200 El Camino Real in what is today the U-Haul building. This store's art deco facade still stands today. (Reg McGovern.)

Retired police chief Clement L. "Mickey" Collins (right) received a check for $221.93, as well as an electric refrigerator and a television set, at a testimonial dinner in 1949. Making the presentation was *Redwood City Tribune* publisher Ray Spangler, treasurer of the committee organized to fete the popular police chief, who had served for 29 years. He was succeeded by Stanley D. Wood. (Reg McGovern.)

For decades, Redwood City was home to a flourishing nursery industry, and vast areas from Horgan Ranch to Valota Road and Redwood Avenue were covered with flower fields and greenhouses. The California Chrysanthemum Growers Association was granted a state charter in Redwood City in 1932. Japanese Americans were responsible for the bulk of the flower production, using growing techniques that allowed the beautiful blooms to survive cross-country shipping to East Coast markets. (Reg McGovern.)

Voter approval of $2.1 million in bond issues cleared the way for construction of Sequoia Hospital at Whipple Avenue and Alameda de las Pulgas. This June 23, 1950, photograph was taken a few months before the 106-bed hospital opened its doors in October. In 1954, when a new 102-bed wing was added, the *Redwood City Tribune* said the average cost of a hospital stay was $33.15 per day, the average total bill: $155.81. (Reg McGovern.)

Collisions like this one on December 28, 1950, involving a Southern Pacific commuter train and a vehicle were an all-too-common occurrence in the 1940s and 1950s. The driver of the vehicle was killed. Today's Caltrain puts forth a tremendous effort to educate the public that car and pedestrian versus train encounters are typically one-sided. (Reg McGovern.)

Five straight days of rain in January 1952 resulted in widespread flooding in Redwood City, engulfing downtown areas. City streets ran like rivers. Crews sandbagged entrances to stores to keep the waters from entering them, but many merchants were forced to close. This photograph shows the water's rise along James Avenue and California Street. Across El Camino Real, Sequoia High School was partially submerged. The unusual sight of a flooded football field led to the photograph below. Youngsters Jerry Heintz and Bob Barrows paddled a canoe around Terremere Field, and Jim Beggs, 1951 Stanford crew coach, gave directions to the gridiron oarsmen from the banks—or the sidelines, as you will. (Both, Reg McGovern.)

A new Safeway located at 2200 El Camino Real was almost fully stocked with merchandise and just days from opening when disaster struck on May 26, 1951. Only one more load of grocery stock, meat, and perishable items remained to be delivered before the planned June 6 opening. But a massive fire called a sudden halt to those plans. Damage was estimated at $200,000. The store subsequently opened on March 19, 1952. (Reg McGovern.)

Redwood City firemen Earl McDaris (left) and Adolph Argilla are pictured outside Firehouse No. 3, located on Second Avenue and Bay Road, on September 12, 1952. Built to serve the industrial area and rapidly growing Friendly Acres residential district, the station was dedicated to the memory of Mark E. Ryan. Fire chief Ryan, who died in 1946, had served for more than 30 years and had also served as mayor. (Reg McGovern.)

This 1953 air view of Woodside Plaza shows the first businesses, a service station and a Lucky Store. Lucky Store was the first store to open in Woodside Plaza (originally along Woodside Road frontage). Other businesses followed during the next few years, including a bowling alley, a Thrifty Drug Store, the Plaza Barber Shop, Imperiale Hardware, Jaye's Restaurant, Stehle's Stationery and Gifts, Mode O'Day, Kirby Shoe Store, and more. (Reg McGovern.)

A Thrifty Drug Store came to Woodside Plaza in March 1954, offering Redwood City shoppers a self-service drugstore with a variety of merchandise, including toys, watches, lamps, jackets, cologne, and more. Such huge crowds turned out for the grand opening that management vowed to get additional checkout lanes installed immediately. (Reg McGovern.)

There were bargains galore as shoppers enjoyed the added convenience of the new stores in Woodside Plaza, especially Thrifty Drug Stores. The retailer featured a fountain grill, and as can be seen, there is not an empty seat at the lunch counter. (Reg McGovern.)

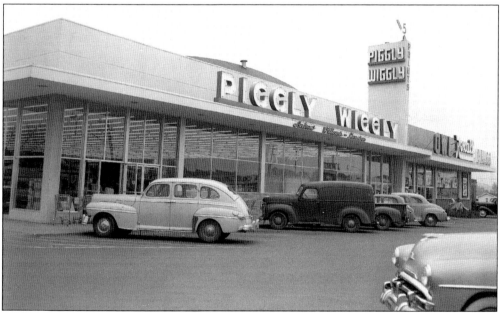

Rapid growth in Redwood City in 1954 prompted the popular grocery chain Piggly Wiggly to open its first store on the peninsula in the Five Points shopping center. The company marked a successful first year in 1955 with a three-day anniversary celebration that included daily quiz shows and an appearance by one of Canada's top yodeling cowboys to sing and entertain. Note the star and Five Points logo on the face of the Piggly Wiggly sign. (Reg McGovern.)

William Faulstitch was promoted to Redwood City chief of police in October 1955, replacing retiring chief Stanley D. Wood. Chief Wood served for more than a quarter century and presented Faulstitch with the 14-karat gold chief's badge he is shown holding in this November 30, 1955, photograph. Faulstitch joined the department in 1943 and was revered by the men and women who served under him and the citizenry alike. (Reg McGovern.)

A California National Guard Armory opened at Community Park in 1949. Pictured in this June 1954 photograph are two local peninsula guardsmen preparing to head out for two weeks of training at the National Guard facility at Fort Hunter-Liggett. (Reg McGovern.)

When the 537th W. T. Grant department store in the chain opened in May 1955, the manager proclaimed that a "miracle of modern merchandising" had arrived at Woodside Plaza. Under one roof, the 17,500-square-foot store offered specialties usually found in separate shops—fashion, dry goods, home-hardware, and a variety store. Specially designed "shop-at-a-glance" counters and display fixtures would present merchandise "for speedy selection or casual inspection." (Reg McGovern.)

When Broadway Market opened in 1956, it was one of the stores in the new Roosevelt Plaza on Roosevelt Avenue at Upton Street, serving expanding residential areas in the western part of the city. The store was operated by brothers Mike and Bill Bouskos and boasted one of the largest frozen food display counters in the United States, ready-wrapped meats, and refrigerated fruits and vegetables. One of the Bouskos brothers' other two markets was on Broadway. (Reg McGovern.)

Assemblyman Carl "Ike" Britschgi (right) served on the Redwood City Council before being elected to the California State Legislature in 1956. He is pictured with Assemblyman Louis Francis of San Mateo on the left and state senator Richard J. Dolwig of Atherton (center) in January 1957 as the three legislators headed off for Sacramento. (Reg McGovern.)

The six-acre Union Cemetery on Woodside Road was established in 1859, and an estimated 40 Civil War veterans are among the 2,400 interred there. From time to time, this historic treasure has suffered unfortunate neglect and vandalism. In an instance in 1957, a life-sized bronze statue erected in 1889 to honor Civil War soldiers was shattered. It is shown here in 1958, repaired and being returned to its pedestal. (Reg McGovern.)

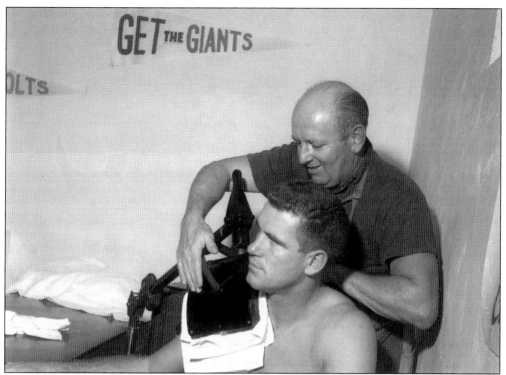

Henry Schmidt, pictured in the San Francisco 49ers training facility in 1957, was a well-liked trainer who originally worked at Santa Clara University and joined the staff when the 49ers moved to their new training quarters and practice facility in Redwood City. The team's training facility was built next to the new Veterans Memorial Building at Red Morton Community Park. (Both, Reg McGovern.)

Work began in 1956 on a 3.8-mile segment of the Bayshore Freeway between Bransten Road in San Carlos to just north of Marsh Road in Menlo Park. This May 1957 air view shows how workmen had leveled and filled the route for the freeway through Redwood City and were progressing toward a mid-1958 completion date. The new freeway passed through the former Frank Tannery property (lower left), and the beginnings of the Whipple Avenue cloverleaf can be seen in the upper center of the photograph. (Reg McGovern.)

The *Redwood City Tribune* campaigned to get the notoriously congested bottleneck at Whipple Avenue and El Camino Real straightened. About the time this photograph was taken, the impending opening of the Bayshore Freeway and the Whipple interchange gave added urgency to the need to correct the problem. The 1957 air view shows two landmark El Camino eateries—the Peanut Stand (white roof) and the Fox Shoppe (on the northwest corner)—with the "Climate Best" sign between the Fox Shoppe and the Standard Station. (Reg McGovern.)

This air view shows southeastern Redwood City in 1951. The long north-south arterial on the left is the old Bayshore Highway. PABCO is on the lower left, and continuing to the right, the city's corporation yard and National Motor Bearing Company are off Chestnut Street and Broadway. The vacant area with the oblong road in the middle is the future Ampex Corporation site. The Friendly Acres neighborhood is at the top of the photograph. (Reg McGovern.)

Completion of the Bayshore Freeway in 1958, coupled with residential expansion on both sides of Woodside Road, only worsened long-standing congestion problems at the Five Points intersection on El Camino Real. Drivers trying to make turns (above, car in the circle) faced a solid stream of traffic. Bumper-to-bumper traffic waited on El Camino (below) for cross-traffic to move, and Main Street was subject to back-ups as well. (Both, Reg McGovern.)

Looking at the Five Points intersection from the air shows just how confusing and dangerous the intersection was, with Woodside Road and Redwood Avenue entering from the west (right side of the photograph) and Spruce and Main Streets intersecting El Camino Real from the east. (Reg McGovern.)

The eventual solution entailed the widening of Woodside Road and an overpass over the reconfigured Five Points intersection and the Southern Pacific railroad tracks in the mid-1960s. The S&W cannery sits to the right of the Woodside Road ramp, and Middlefield Road is just visible in the upper left corner of the photograph. (Reg McGovern.)

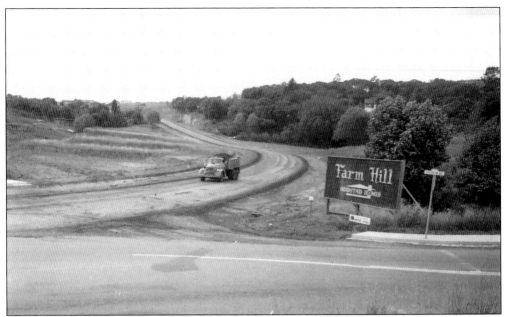

Oddstad Homes developed the Farm Hill subdivision in the hills of the city and was completing houses at a rate of three a day in a particularly busy period in the fall of 1956. Residents were anxious to see the long-planned extension of Farm Hill Boulevard to Jefferson Avenue get completed and were assured in May 1957, when this photograph was taken, that the work would be accomplished via an assessment district. (Reg McGovern.)

Built on the southern end of El Camino Real in 1922 by two Stanford students, the Nipa Hut had an island theme that made it an unusual peninsula landmark. The round-thatched hut featured a unique frozen orange beverage, and patrons could sit and sip their drinks under the nipas. The Nipa Hut was turned into a restaurant after World War II, and it was razed in 1960 to make way for a steak house. (Reg McGovern.)

Redwood City's first drive-in theater opened in June 1961 on East Bayshore Road off Whipple Avenue, with a giant screen said to be the largest on the peninsula. The drive-in, built by the Syufy Enterprises theater chain, had enough spaces for 1,100 cars, and each was equipped with an electric heater for in-car use. The Century Park 12 Theater later replaced the drive-in. (Reg McGovern.)

This train station had been relocated in 1937 from the northeast side of the tracks to the west side, where commuters waited to board Southern Pacific trains to go to work. Damaged in a fire in 1979, the building was razed. The new Redwood City Transit Center, completed in 1995, featured a passenger shelter architecturally reminiscent of the historic station. (Reg McGovern.)

Peninsula Transit Lines was a private company providing bus service in Redwood City when this photograph was taken in 1964. The roof of the Redwood City Southern Pacific station is visible in the background. The San Mateo County Transit District consolidated bus services into a county-wide agency in 1976. (Reg McGovern.)

In 1966, the Redwood City Criterium race was the place to be for top competitors in the sport. The streets around Ampex were the scenes for the early races, and it was one of the mid-1960s Criteriums where videotape was first used to capture a sporting event. The race was later moved to the streets of downtown. (Reg McGovern.)

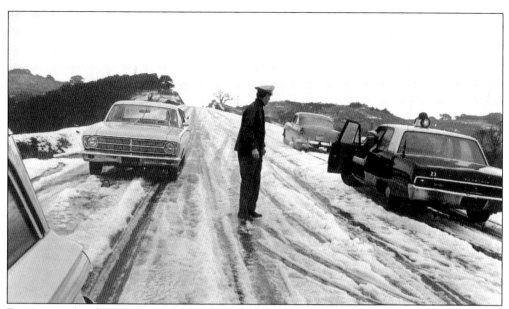

Even a city that boasts about its celebrated climate is not immune to winter weather and, on rare occasions, that has included snow. Although snow along Skyline Boulevard is not all that unusual, it is a cold day in Redwood City when the snow line reaches Edgewood Road, as seen in this pre–Interstate 280 photograph. (Reg McGovern.)

Heiress Patricia Hearst has the dubious distinction of being one of the San Mateo County Jail's most famous prisoners. Kidnapped by the Symbionese Liberation Army in 1974, Hearst allegedly "joined" the group during her captivity. Arrested in 1975, she was incarcerated in Redwood City and later convicted of bank robbery. Wearing a T-shirt appealing for a presidential pardon that she eventually received, she is pictured here in 1979 with her future husband and bodyguard, Bernard Shaw. (Reg McGovern.)

EPILOGUE

REG McGOVERN: SEEING THE CITY THROUGH THE LENS

Born in a house on Arch Street that is still standing, Reginald McGovern grew up to chronicle his hometown in thousands of pictures spanning six decades. Starting as a teenaged amateur, he taught himself with a primitive pinhole box camera, plus the Kodak folding camera his mother packed along on vacations. By the time he was a Sequoia High School student, McGovern was earning money selling sports photographs to team members, as well as picking up commercial photography work and freelancing for the *Redwood City Tribune*.

The longest time McGovern has ever lived away from Redwood City came during World War II, when he served in the South Pacific aboard the U.S. Coast Guard ammunition ship *Murzim* (AK-95). Four years later, the waning war brought him back home, where he worked a few months in the 12th Naval District photo lab in San Francisco before being discharged.

The turning point in McGovern's professional life came in 1945, when *Tribune* publisher Ray Spangler decided the paper was doing well enough to hire its first staff photographer. Spangler offered his friend "Reggie" $40 a week—big money in those days. And if one could be born to a job, the incurably curious, resourceful cameraman with a nose for news was quite simply a natural. Over the years, McGovern covered Redwood City life—from murders to fashion shows and from fires to protests, earning a string of awards in the process. The Associated Press voted his shot of a tank explosion during a fire at Chemical Affiliates, Inc., in San Carlos, the best newspaper picture of 1950 in California. He won top awards in the AP's California-Nevada competition seven times in eight years.

In the age of digital photography, the results McGovern achieved with a Speed Graphic camera seem all the more remarkable. Photographers had to shove film holders in and out of the back of the bulky cameras. Since each holder held just two pieces of film, McGovern had to "get the picture" in just a few shots. The first full-time photographer hired by a peninsula newspaper, he transitioned from 4-by-5-inch negatives to locally pioneer the use of 35-mm cameras and color.

Not one to just report for a photo assignment, McGovern cultivated a wide range of sources and dug up stories and scandals on his own. During the pre-television days, the competition among print photographers was intense. "When a big story broke, it was a mob scene," he recalled. "All the photographers trying to angle for position, a good shot, and outmaneuver the other guy. They were fun years."

Nonetheless, many of McGovern's photographs in this book didn't spring from the big headlines of the day and aren't necessarily award winners. Rather these are scenes of everyday life in a California small town during a critical formative period: downtown storefronts, men tanning hides or loading ships, kids diving into the swimming pool, or aerial views of a city that was changing imperceptibly year after year.

McGovern's sense of humor and some personal eccentricities made him one of the peninsula's best-known characters during the 36 years that he worked for the *Tribune*. He set his own dress code, wearing Bermuda shorts for most of the year and maintenance man jumpsuits in the winter. As he is a fanatical animal lover, his favorite assignments were to the Peninsula Humane Society or MarineWorld/Africa USA, taking pictures of homeless kittens or tiger cubs. Another major interest—brass bands—led him to start his own recording company in 1954, specializing in college and marching bands. Still in business, the company keeps McGovern, now 88, busy, particularly during football season.

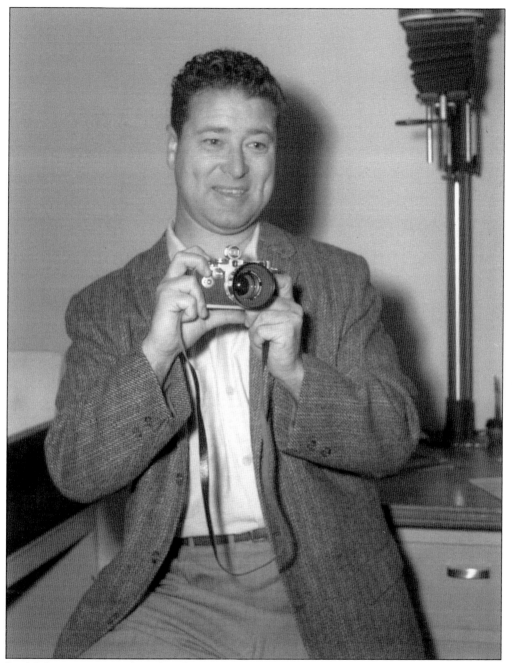

Reg McGovern is seen in the *Redwood City Tribune* offices between assignments. (McGovern Collection.)

DISCOVER THOUSANDS OF LOCAL HISTORY BOOKS FEATURING MILLIONS OF VINTAGE IMAGES

Arcadia Publishing, the leading local history publisher in the United States, is committed to making history accessible and meaningful through publishing books that celebrate and preserve the heritage of America's people and places.

Find more books like this at
www.arcadiapublishing.com

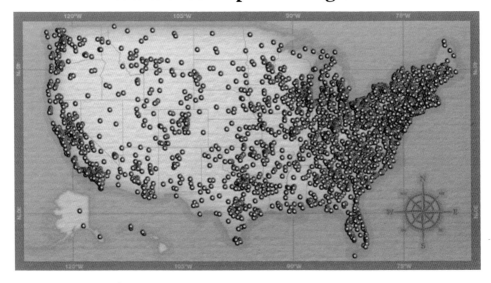

Search for your hometown history, your old stomping grounds, and even your favorite sports team.